The Potato Eaters

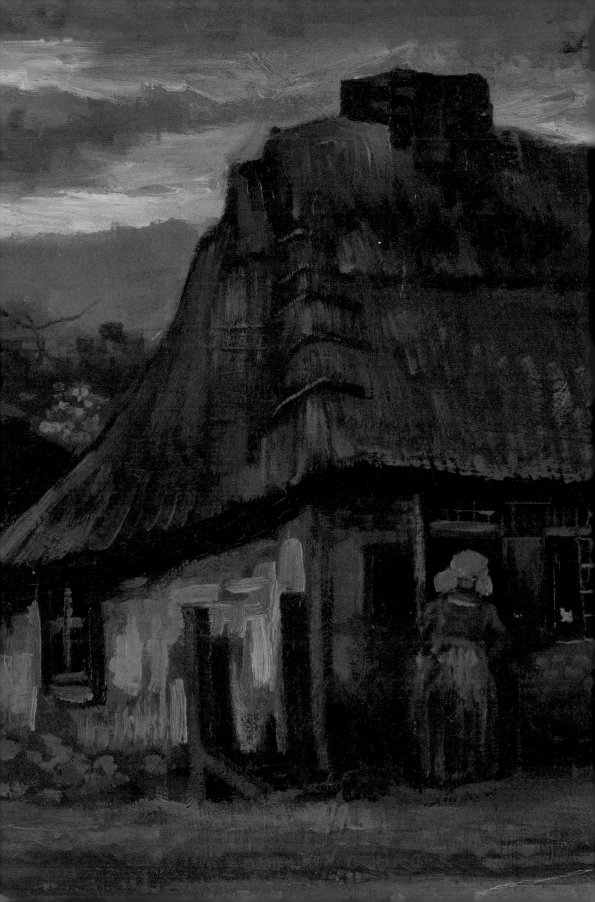

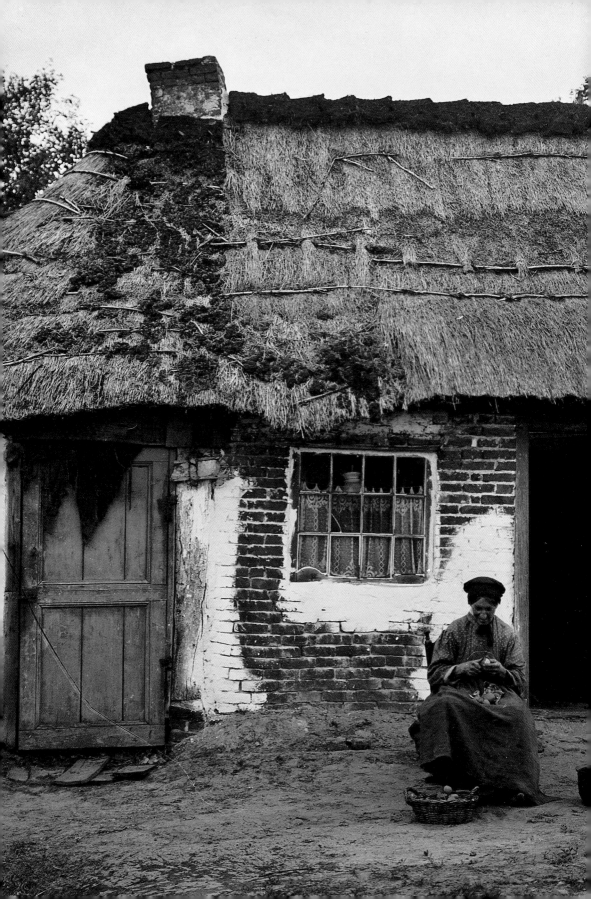

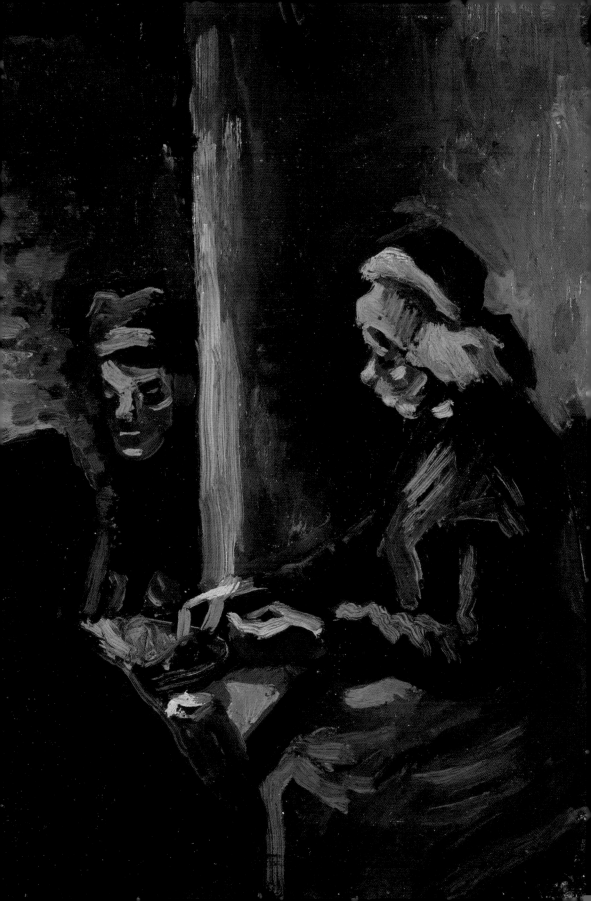

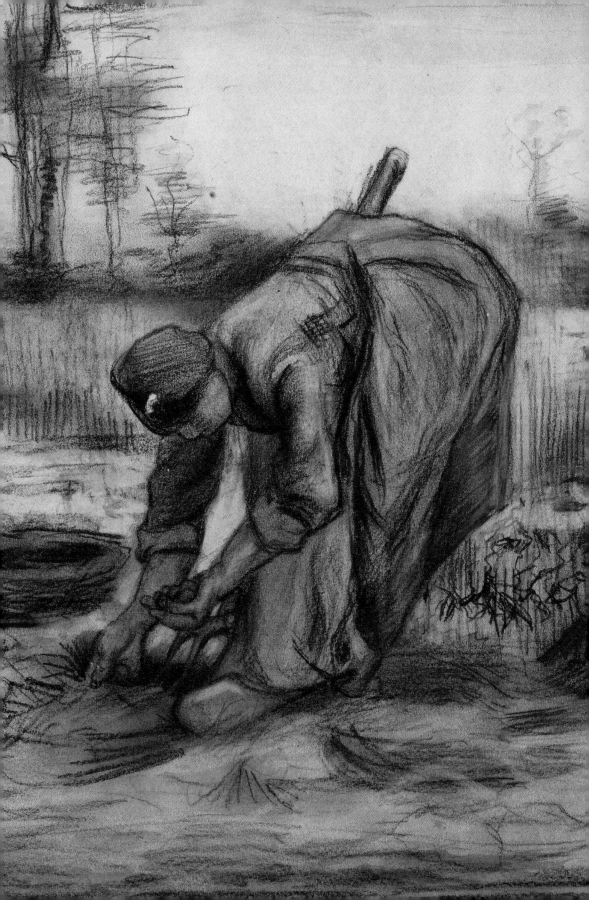

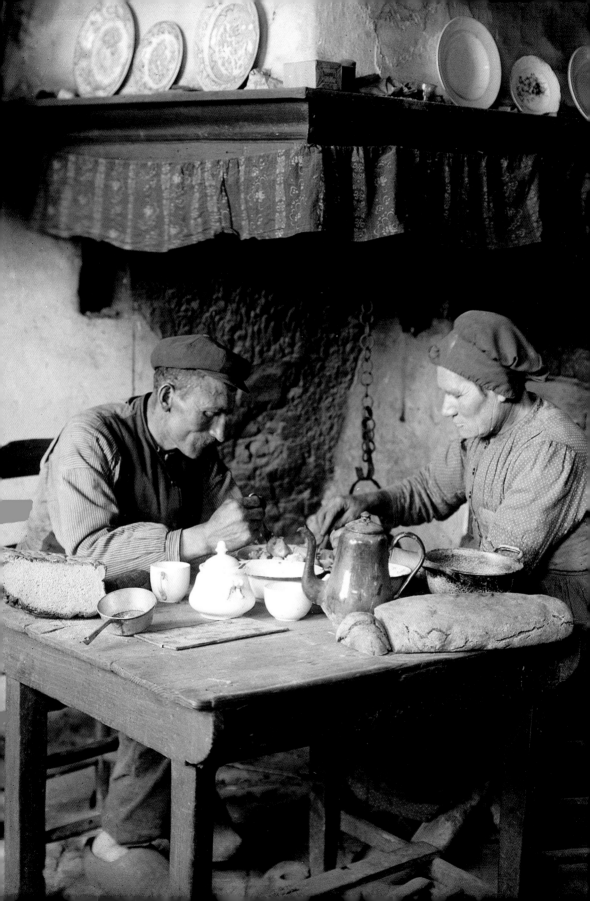

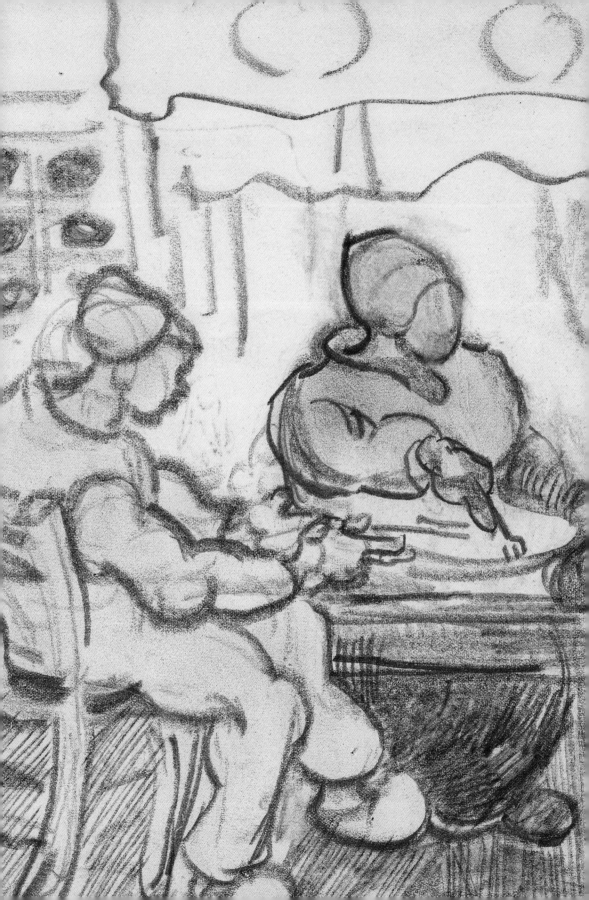

bezig hen op nieuw aan de bac
een schotel aardappels.
Ik kom er daarnet van thuis – en h
lamplecht nog gewerkt en aan –
ik het by dag ditmaal heb aange.

Ziehier hoe de compositie nu gewor
Ik heb het op een vry groot doek geschilderd
~~licht~~ en zooals de Schets nu is zit gele
leven in –

The Potato Eaters

VAN GOGH'S
FIRST MASTERPIECE

Bregje Gerritse

VAN GOGH MUSEUM

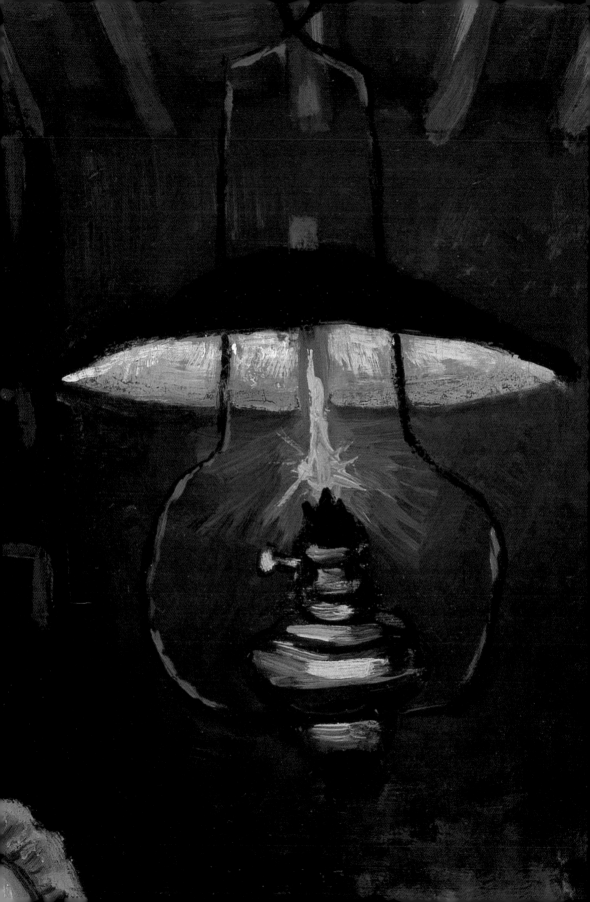

Contents

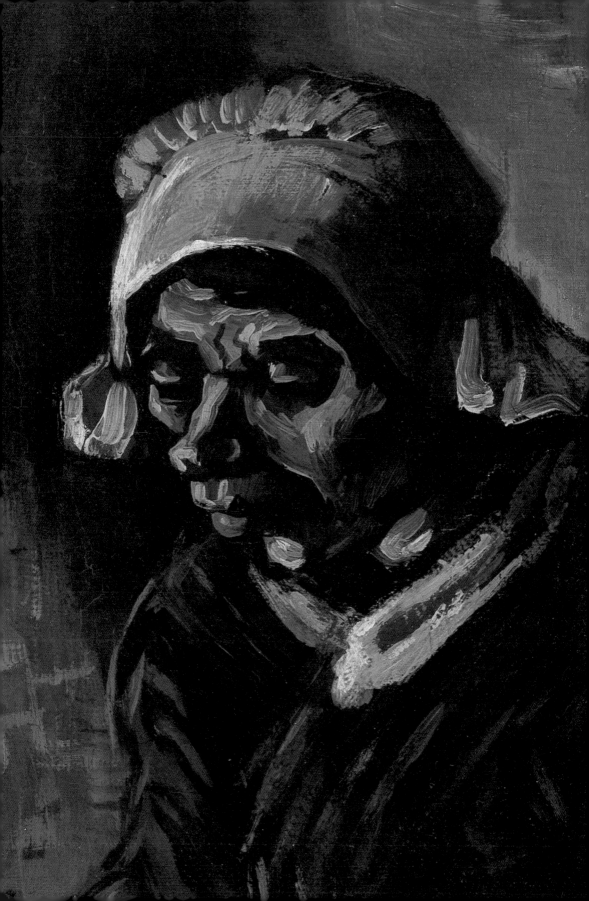

Foreword

Painting *The Potato Eaters* in 1885 was an enormous challenge for Vincent van Gogh, and he was acutely aware of this. He spent months preparing his 'masterwork', hoping it would provide his *entrée* to the Paris art market. He chose a figure painting, traditionally viewed as superior to a landscape, for his submission to the Salon, the most important exhibition for visual artists at the time. He even decided to make a group composition – a form he had yet to master. This ambitious piece was intended to represent the harsh but honest life of rural labourers, and this is how the idea for *The Potato Eaters* was born.

This book and the exhibition focus on Van Gogh's painting of a peasant family eating their evening meal. The unique genesis of the work offers a wealth of stories and gives the Van Gogh Museum an ideal opportunity to bring together and exhibit the paintings and drawings that were essential to its creation. Unlike the fairly instinctive way in which he had previously worked, Van Gogh decided to apply an academic method to the painting of *The Potato Eaters*, and he prepared it meticulously with several studies, drawings and sketches.

Various exhibitions in recent years have concentrated on specific masterpieces by Vincent van Gogh, such as The Art Institute of Chicago's *Van Gogh's Bedrooms* in 2016 and the Van Gogh Museum's own *Van Gogh and the Sunflowers* in 2019. After having presented several exhibitions at the museum that emphasized Van Gogh's works from his later years in France, we are now focusing on his Dutch period. It was in the province of North Brabant that the artist created *The Potato Eaters*, the first picture that he himself considered to be a major work. *The Potato Eaters: Mistake or Masterpiece?* gives Van Gogh's figure painting from Nuenen the attention it deserves.

The concept behind the exhibition was developed by our talented researcher Bregje Gerritse, who is also the author of this publication.

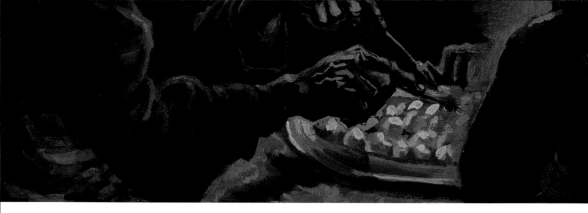

Her fellow researchers Louis van Tilborgh and Teio Meedendorp and Senior Curator Nienke Bakker helped her to devise and elaborate the approach, and supported her enthusiastically with their expertise.

The present exhibition mainly features works from the Van Gogh Museum's collection and would not have been possible without the Vincent van Gogh Foundation, which owns the vast majority of the collection. We would also particularly like to thank the Royal Museums of Fine Arts of Belgium in Brussels for generously allowing us to borrow works. The museum is extremely grateful to a number of partners in Nuenen, including Museum Vincentre and Salon Nune Ville, for their cordial support and trust. Thanks are also due to the exhibition designers Pièce Montée, designer Janpieter Chielens, Tijdsbeeld publishers for the book production and our colleagues at the Van Gogh Museum who contributed to this project. Every one of them worked tirelessly from home to make this exhibition and publication a success.

We are hugely grateful to the supporters of this exhibition. The museum is indebted to the Ministry of Education, Culture and Science and to our principal partners the VriendenLoterij, Van Lanschot and ASML for their generous support. We also extend our thanks to exhibition partners Hyundai, CêlaVíta and The Sunflower Collective.

Having completed his *Potato Eaters*, Van Gogh immediately sent it, full of hope, to his brother Theo in Paris. The paint was still not entirely dry by the time the canvas arrived. Yet the success Vincent dreamed

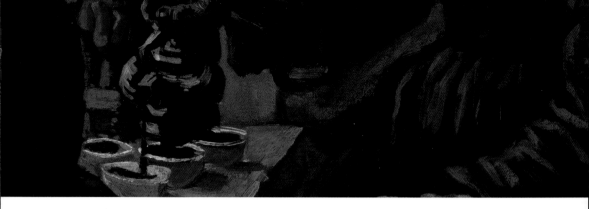

of failed to materialize. The work was widely criticized, including by his good friend Anthon van Rappard. Although *The Potato Eaters* ended up hanging unsold above the fireplace in Theo's Paris apartment, Vincent continued to stand squarely behind his canvas, even after he had moved to France and developed considerably as a painter. He was proud of his achievement, refused to be discouraged as an artist and continued to experiment. As he wrote to one of his critics: 'I keep on making *what I can't do yet* in order to learn to be able to do it' [528].

We hope Van Gogh's motivation and perseverance will inspire readers of this book to take a fresh look at what is now a world-famous painting and to understand his faith in *The Potato Eaters*. As he wrote to his sister Willemien in October 1887, '[it] is after all the best thing I did' [574].

Emilie E.S. Gordenker
Director of the Van Gogh Museum

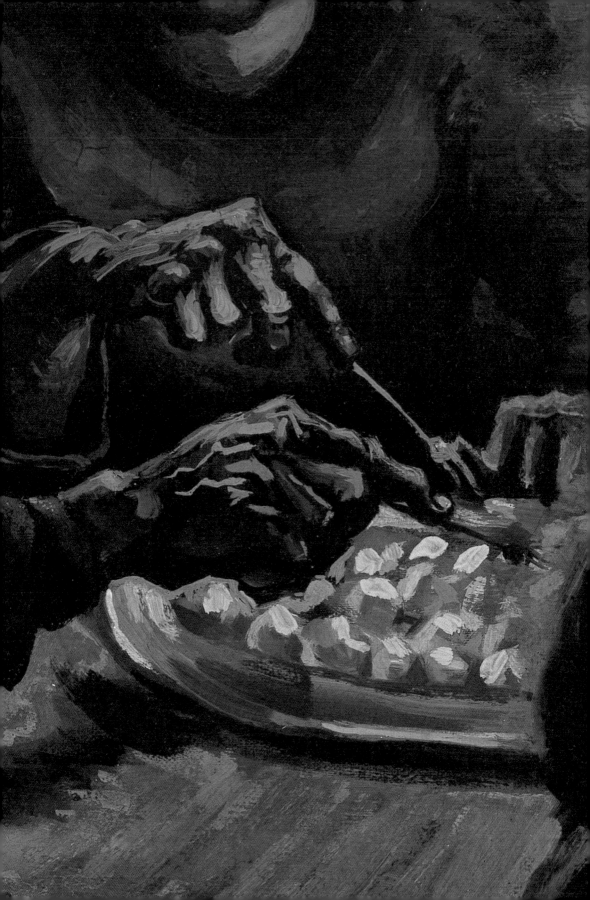

VAN GOGH'S
POTATO EATERS

Many of Vincent van Gogh's works are today viewed as masterpieces, but this is not an opinion that was shared by the artist himself. In his eyes, only four of his paintings were truly important works, and even then he hesitated to call them 'masterpieces'. They were *The Bedroom*, *Sunflowers* and *Augustine Roulin* (*La berceuse*) – all painted in the southern French town of Arles in 1888–1889 – and *The Potato Eaters*, which he completed in the Brabant village of Nuenen in 1885.

The Potato Eaters is a painting in dark, earthy colours of a simple peasant family sharing a meagre supper of potatoes and coffee. An oil lamp illuminates the scene, highlighting their weather-beaten faces and hands. Van Gogh hoped that this first attempt at a masterwork would demonstrate what he had achieved as an artist in the space of just over four and a half years, as well as the kind of painter he was: one who preferred to depict the harsh reality of honest rural life rather than that of the modern city.[1] The painting can be regarded as the culmination of the first half of his career, which he spent in the Netherlands. While *The Potato Eaters* seems far removed from his focus after moving to Paris, he remained attached to it, even after embarking on an entirely new artistic course.

The immense hopes that Vincent pinned on *The Potato Eaters* are revealed in his intensive correspondence at the time with his brother. He was desperately keen for Theo – who was employed in Paris by the art dealers Boussod, Valadon & Cie – to show the painting to important buyers, so that he would be able to establish his reputation with it.

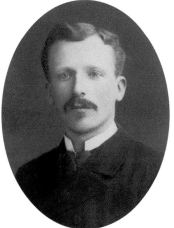

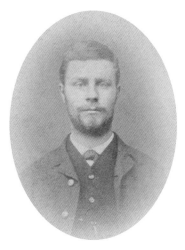

Sadly, the response to his work was considerably less positive than he had hoped. It even included some merciless criticism from an unexpected quarter – his artist-friend Anthon van Rappard (1858–1892).

All the same, Van Gogh did not give up. Convinced as he was that *The Potato Eaters* successfully conveyed his message about the raw honesty of rural life, he forgave himself the mistakes and shortcomings in his painting technique: 'it might well prove to be a REAL PEASANT PAINTING. *I know that it is.* But anyone who would rather see insipidly pretty peasants can go ahead. For my part, I'm convinced that in the long run it produces better results to paint them in their coarseness than to introduce conventional sweetness' [497].

Van Gogh remained convinced of the quality of the painting – so much so that he expressed the wish five years later to make a new version of it. The enormous development he had undergone as a painter in the meantime did not prevent him from valuing *The Potato Eaters*. While the new version never materialized, the idea of redoing it shows that he continued to view the painting, with which he had sought to introduce himself as an artist, as one of his most accomplished and precious works.

1
Vincent van Gogh at
the age of nineteen,
January 1873.
Van Gogh Museum,
Amsterdam

2
Theo van Gogh, 1889.
Van Gogh Museum,
Amsterdam

3
Anthon van Rappard,
c. 1880.
Van Gogh Museum,
Amsterdam

ART MARKET

Van Gogh was troubled for years by the question of when his paintings would be good enough for the market. He wanted nothing more than to sell his works and, with an art dealer as a brother, this was certainly feasible in theory. Having decided to become an artist at the age of twenty-seven in 1880, Van Gogh began to send his work to Paris fairly regularly from 1881 onwards so that Theo could gauge his progress.[2] Vincent was largely self-taught and relied heavily on his brother to judge the quality of his work. He hoped to make money reasonably quickly as an artist, but this did not occur. Time after time, Theo criticized the paintings he sent, telling him that they were not sufficiently accomplished to impress his fellow art dealers.

After living in The Hague for two years, Van Gogh yearned for a rural setting. He was constantly short of money too, despite the allowance he received from Theo. In late 1883 he took the decision to move back in with his parents at the eighteenth-century parsonage in Nuenen, where his father Theodorus van Gogh was a minister of the Reformed Church (figs. 4, 6, 7).[3] He was allowed to use **'the little room at home where the mangle is'** for his studio [413].

Even though he could now count on free board and lodging, Vincent continued to rely on Theo for his other expenses. Unhappy about the financial burden he was placing on his younger brother, he suggested to Theo that as of the spring of 1884, he would send all his paintings and drawings to him in Paris, so that he would be able to think of his allowance **'as money I've earned'**. Not only did he hope to improve fraternal relations in this way, he also viewed it as an important opportunity to showcase his work and **'to send it into the world'** [422].

He dispatched a first consignment of drawings to his brother in February 1884, but Theo once again failed to respond enthusiastically or to increase his sales efforts, causing renewed strife between them:

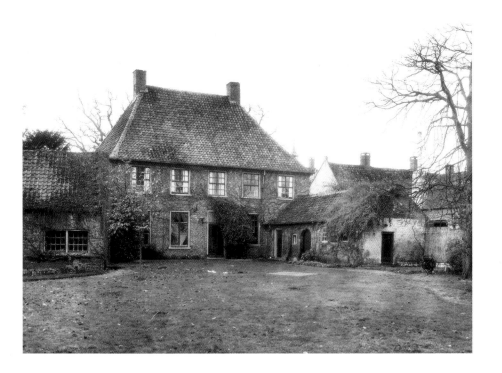

4

The rear of the vicarage in Nuenen. Van Gogh's studio was in the low outhouse on the right. Van Gogh Museum, Amsterdam

5

Sketchbook in which Van Gogh made drawings and notes during his Nuenen period, November 1884–September 1885. Van Gogh Museum, Amsterdam

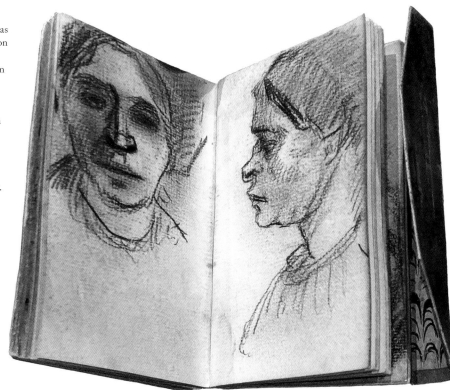

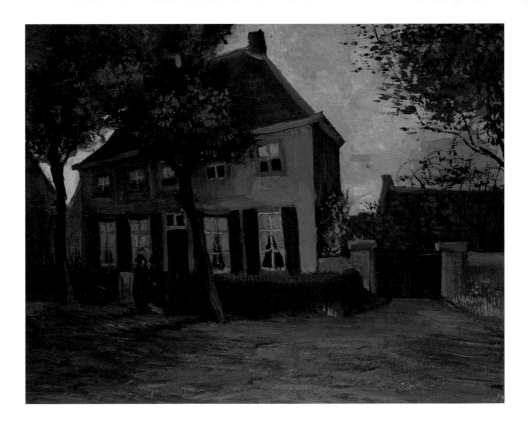

6

Vincent van Gogh,
The Vicarage at Nuenen,
September–October
1885. Van Gogh
Museum, Amsterdam

'I think that what you say is true, that my work will have to get much better, but at the same time also that your efforts to do something with it might also be a little more decisive. You have *never yet* sold *a single thing* of mine – not for a lot or a little – and IN FACT HAVEN'T TRIED TO YET' [432].

Vincent was not one to forgive and forget and while his brother continued to send him a monthly allowance, no further drawings or paintings were mailed to Paris, despite the brothers' agreement. He held onto important works in Nuenen, including his *Avenue of Poplars in Autumn*, a large and melancholy study done in 1884 (fig. 8).[4] And rather than Theo, it was to Van Rappard that he sent a series of his most beautiful pen drawings from that same year (fig. 10). 'I do hope to sell in time', he wrote, and undertook to keep working steadily [433]. For his part, Theo tried to persuade him that his work first needed to improve considerably and that it was certainly not suitable as yet for a Parisian audience.[5]

After a year had passed, Theo made a conciliatory gesture, asking Vincent out of the blue in late February 1885 whether he had a suitable piece to submit to the Paris Salon, at which over two thousand jury-selected paintings were exhibited at the Palais des Champs-Elysées from 1 May each year. It was undoubtedly a strategic move by Theo, who would not then be risking his own reputation as an art dealer if his brother's work was poorly received.[6] The request for a picture for the Salon caught Van Gogh entirely unprepared and he had nothing suitable in his studio. He had spent most of the winter painting local rural people and viewed the works he had produced so far as studies. The two months left before the opening of the Salon did not seem enough

7

Vincent van Gogh, *Congregation Leaving the Reformed Church in Nuenen*, January–February 1884 and autumn 1885. Van Gogh Museum, Amsterdam

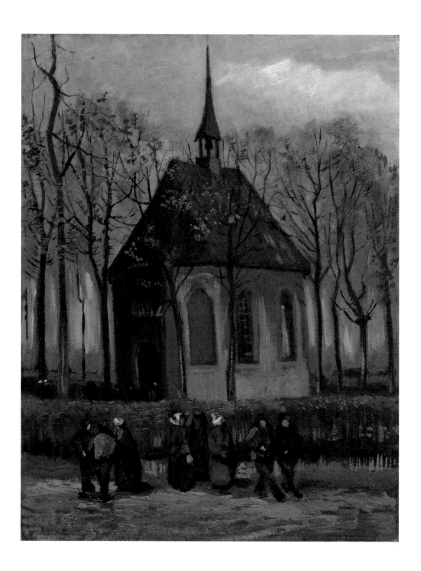

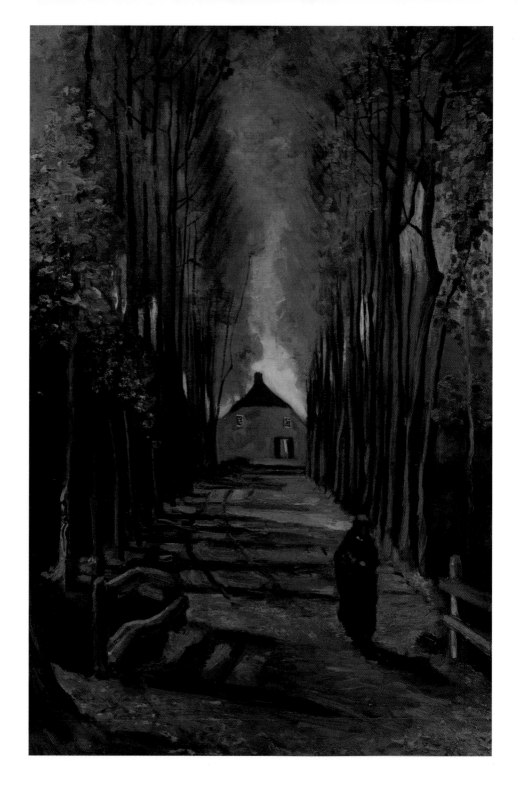

8

Vincent van Gogh,
Avenue of Poplars in
Autumn, October 1884.
Van Gogh Museum,
Amsterdam

25

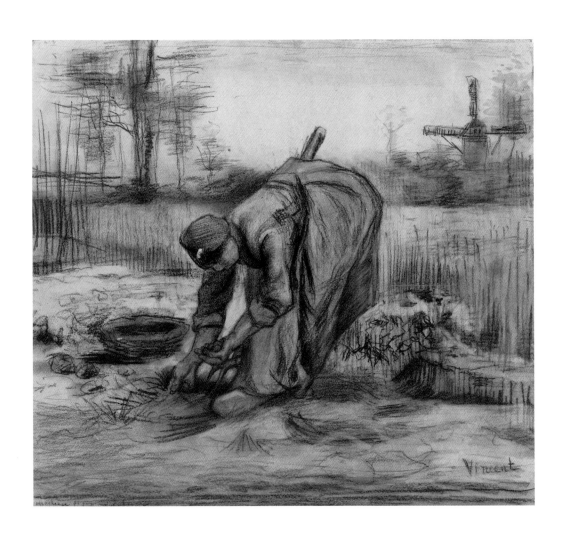

9

Vincent van Gogh,
*Peasant Woman Lifting
Potatoes*, August 1885.
Van Gogh Museum,
Amsterdam

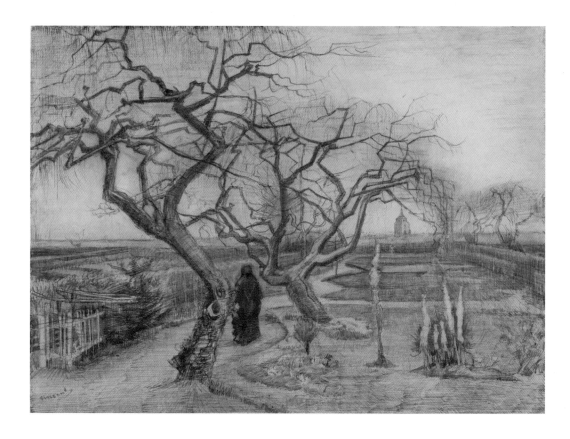

10

Vincent van Gogh,
Winter Garden, March
1884. Van Gogh
Museum, Amsterdam

time for him to prepare anything.[7] This can hardly have been a surprise to Theo who, as an art dealer, must have been perfectly aware that it was good practice to devote months, if not an entire year, to producing a Salon submission. Van Gogh was nevertheless gripped by the idea of a painting worthy of inclusion and by the end of March had come up with a scheme for a group composition on a peasant theme, painted from life. On 6 April 1885, he wrote for the first time about his plan for a figure painting **'with the peasants around a dish of potatoes in the evening'** [490]. The idea of *The Potato Eaters* was born.

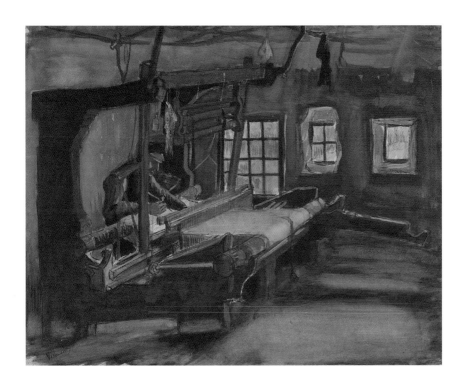

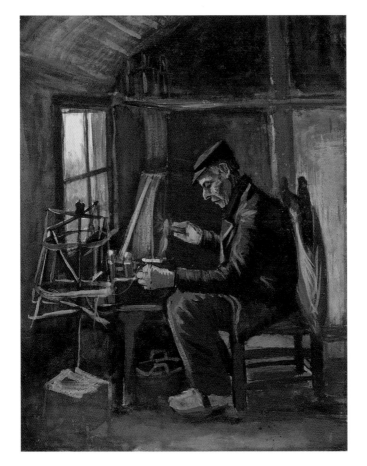

11
Vincent van Gogh,
Weaver, December
1883–August 1884.
Van Gogh Museum,
Amsterdam

12
Vincent van Gogh,
Man Winding Yarn,
May–June 1884.
Van Gogh Museum,
Amsterdam

A PEASANT FIGURE PAINTING

Van Gogh was clear from the outset that *The Potato Eaters* ought to be a figure painting with peasant life as its focus – a logical choice given where he was living and the painters whom he admired. It would enable him to establish his reputation in Paris as a peasant painter in the tradition of the time.

The area around Nuenen provided Van Gogh with a wealth of subject matter: **'I don't think there's been a day since I've been here when I haven't sat working with the weavers or peasants from morning till night'** [422]. Nuenen was a small community of around 2,500 people in the east of North Brabant province. For the most part, the rural folk Van Gogh chose to depict were impoverished smallholders with a few cattle. This was not enough to sustain them, so they also worked as labourers (fig. 9). The weavers, who were even worse off than the farmworkers, mostly worked at home.[8] The complexity of the looms combined with the small rooms in which they were set up made them an interesting and challenging new motif for Van Gogh (fig. 11).[9] Related activities such as spinning and spooling yarn were also welcome subject matter with which he could expand his repertoire (fig. 12), prompting him to write that **'I desire nothing other than to live deep in the country and to paint peasant life'** [490].

It was precisely this aspect that had characterized the nineteenth-century painters he admired. Van Gogh hoped that *The Potato Eaters* would place him in the tradition of the French Barbizon artists, who lived and worked in the heart of the countryside and recorded rural life.[10] Their semi-realistic works for the Salon glorified the lives of peasants. Where history paintings – works depicting mythological, Christian or historical narratives – had once brought international fame to painters such as Theodore Géricault (1791–1824) and Eugène Delacroix (1798–1863), genre pictures devoted to contemporary life

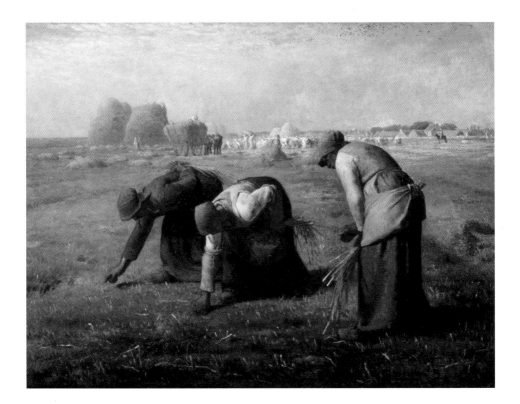

were now popular, with peasants and workers as favourite themes. Art of this kind enjoyed particular success on the European market in the second half of the nineteenth century and so it was natural for Van Gogh to choose a scene from peasant life for his first Salon-worthy piece, in the tradition of the Barbizon painters.

His greatest example within that group was Jean-François Millet (1814–1875), who depicted everyday rural scenes and poetically represented the close relationship between human beings and nature in his paintings (fig. 13). Van Gogh had read in Alfred Sensier's biography of Millet that the artist had grown up in a simple working-class family and that this had convinced him that only painters who were deeply immersed in peasant life could capture it successfully. Like 'Père Millet', Vincent hoped to be 'inspired by the surroundings in which one happens to be', a conviction that matched his own ambitions perfectly [430].[11]

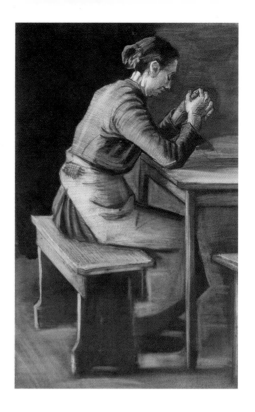

Van Gogh lacked the skills, however, to create large and convincing figure paintings *à la* Millet, and so he turned to interiors – a genre with which he was familiar thanks to his studies of weavers. These offered a better fit not only with his abilities as a painter, but also his immense appreciation of domestic and family life, which he had praised so highly while living in The Hague with Sien Hoornik and her children. Moreover, it is noteworthy that the many drawings for which Sien posed included some in which Van Gogh showed her saying a prayer before a meal (fig. 14). The motif he chose for *The Potato Eaters* was deliberately in keeping with this old, familiar theme.

Peasant meals were already a popular subject, thanks in particular to Jozef Israëls (1824–1911), one of the best-known Dutch painters of the period. He belonged to the Hague School, the Netherlands' answer to Barbizon, and a group of artists of whom Van Gogh was likewise a big admirer. Israëls's paintings of peasant families at the supper

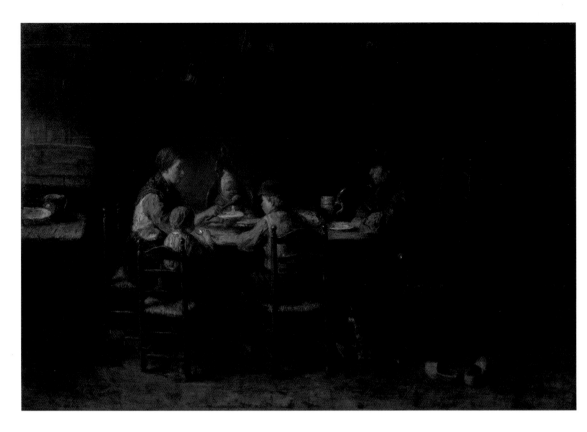

table symbolized the sober lives of hard-working ordinary people, and Vincent was struck by one in particular a year and a half before he left The Hague for Nuenen: 'a small one with 5 or 6 figures, I think, a labourer's family at table' [211] (fig. 15). By choosing to depict a peasant meal, therefore, Van Gogh was consciously following in Israëls's footsteps.

He found an example for the atmosphere of *The Potato Eaters* in the work of Charles Degroux (1825–1870), an artist born in France but who grew up and worked in Belgium. Rather than the history paintings for which Degroux was best known, Vincent was drawn to his 'simple Brabant types' in works like *Saying Grace* (1861) and *The Poor Bank* (1854), which he had been able to admire at the Musée des Beaux-Arts in Brussels during his time there in 1881 (fig. 16).[12] Van Gogh was

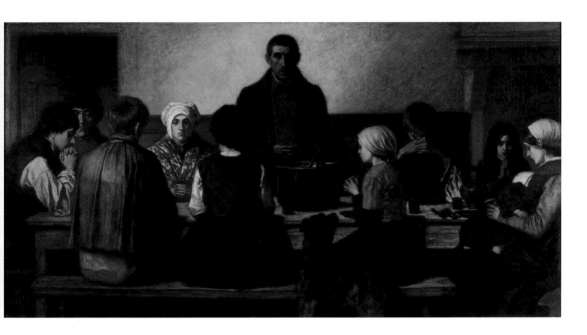

16

Charles Degroux,
Saying Grace, 1861.
Royal Museums of
Fine Arts of Belgium,
Brussels

drawn to the Belgian artist's 'realism that has character and a sincere sentiment' [476]. Degroux was 'one of the *good Milletesque masters*' – which he himself also aspired to become [493].[13] Towards the end of 1884, Van Gogh went so far as to write that he was thinking of his older colleague *'more than ever* these days' [476]. *Saying Grace*, a monumental depiction of peasants around a table, was undoubtedly on his mind when he opted for a comparably simple rendering of the theme in *The Potato Eaters*.

Ik vind hem zeer oprecht en degelyk ~~en geloof dat~~ ~~juist als~~ hy schynbaar ~~snel~~ er snel averheengeloopen is hy niet minder raisonable en juist in zyn teekening is gebleven après tout. Hy is een van die mannen die ik niet persoonlyk ken en toch als ik als van hem zie kan ik me ~~toen~~ voorstellen hoe hy 't gemaakt heeft.

Zendt gy 't schy van Blommers van den Salon (November.) met mooi 't jaar 't schy nu maar wel de reproductie. Ik vind het net als of 't van Bakar was en meer prasser er in en als dramatisch dan B. gewoonlyk heeft.

Op dit oogenblik heb ik niet minder dan 7 à 8 stuks teekeningen onder handen van 1 meter zoowaar in afmeting. Dat ik dus tot over de ooren in 't werk zit zult ge u wel kunnen denken. Maar ik heb zoo'n hoop juist door dezen tyd van spanning myn hand wat vaardiger te maken.

Zoo byvoorbeeld begint den ~~teekenen~~ die ik had om met houtskool te werken met den dag meer weg te gaan. Dat ligt ook daaraan dat ik iets op gevonden heb om de houtskool te fixeeren en dan met iets anders bv. 6 v. Druk inkt er over heen.

TROUBLESOME GROUP COMPOSITIONS

From the outset of his career, Van Gogh hoped to achieve success with large, carefully devised figure pieces. Yet it would prove a difficult task. After his first faltering attempts, he allowed himself a considerable amount of time to study figures individually, to enable him to develop his skills first. While his figure drawings showed evidence of steady progress, group compositions remained overly ambitious. Compositions such as *The Entrance to the Pawn Bank, The Hague* (1882) are awkwardly constructed (fig. 18). Van Gogh lacked the skill to combine figures believably and to mould them into a group, let alone have them interact with one another.

In 1883, Vincent boldly embarked on his first larger painted figure piece, *Potato Grubbers*. He informed Theo that 'I'm working on a painted sketch for potato grubbers. I hope it comes off' [373] (fig. 17). The well-intentioned composition with its figures in a row was largely unconvincing, however, and he left the work unfinished.[14] His inability to combine several figures was apparent once again a year later, when he began to paint designs for decorative scenes from peasant life for his acquaintance Antoon Hermans from Eindhoven (fig. 19).[15]

17

Letter from Vincent van Gogh to his brother Theo with a sketch of *Potato Grubbers* (verso), c. 27 June 1883. Van Gogh Museum, Amsterdam

18

Vincent van Gogh, *The Entrance to the Pawn Bank, The Hague*, March 1882. Van Gogh Museum, Amsterdam

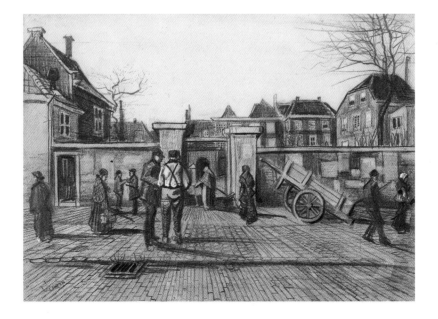

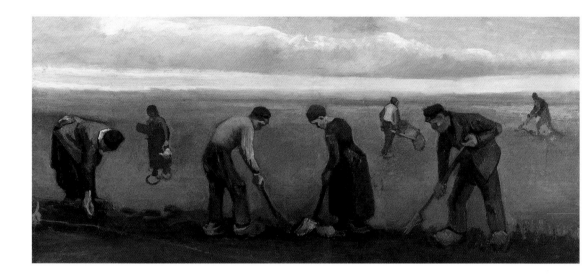

Group compositions were the talent *par excellence* of the French painter Léon-Augustin Lhermitte (1844–1925), who had made his name with realistic, large-scale depictions of rural life. Vincent expressed his admiration to Theo on numerous occasions: 'I see (in details in heads and hands, for instance) how artists like Lhermitte must have studied the peasant figure not only from a fairly great distance but from very close to, not *now*, while they create and compose with ease and certainty, but *before* they did that' [485] (fig. 20). The usual method for creating a group composition was to assemble it on the canvas from sketches and studies – a skill that Lhermitte possessed in abundance and which Vincent similarly hoped to master. What made Lhermitte so good at this, Van Gogh believed, was that he studied the peasants very closely. What he had in mind, therefore, was to compose a painting based on all manner of preparatory studies and observations [485].

19

Vincent van Gogh, *Peasants Planting Potatoes*, August–September 1884. Kröller-Müller Museum, Otterlo

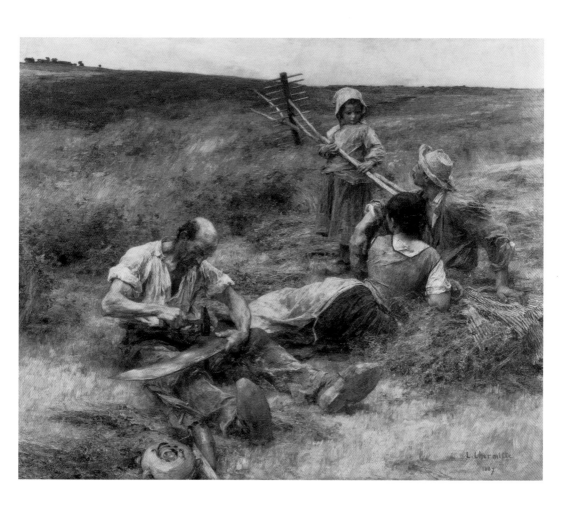

20
Léon-Augustin Lhermitte,
Haymaking, 1887.
Van Gogh Museum,
Amsterdam

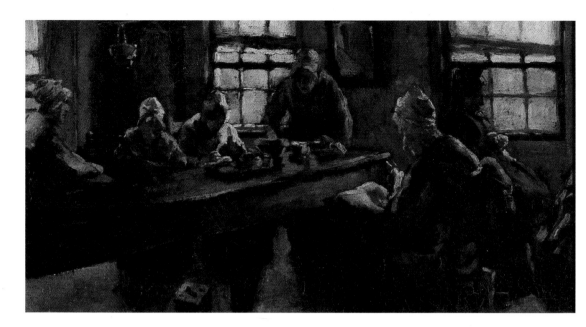

Anthon van Rappard, his friend and brother-in-art, was already more advanced when it came to composing in this way and when Van Gogh visited him in Utrecht at the end of 1883, he saw a study for a group composition with five figures sitting around a table, which he thought 'VERY GOOD' [416]. The work, titled *The Old Women's Home in West-Terschelling*, managed to 'get to the heart of things' (fig. 21). He told Van Rappard that this was precisely what he considered so important: that it was not a question of technical skill but rather of 'subject' and 'character', declaring that '*There are however* art lovers who do, after all, appreciate precisely those things that have been painted with emotion' [439]. He mentioned his colleague's work in several other letters too, his admiration bolstering his conviction that his own attempt to paint a first 'masterwork' should provide the challenge for tackling a group composition.

21

Anthon van Rappard, *The Old Women's Home in West-Terschelling*, 1884. Kunstmuseum, The Hague

METICULOUS PREPARATION

Although Van Gogh often worked in an unconventional manner, he opted at the beginning of April 1885 for a traditional, academic approach for *The Potato Eaters*. He would use preliminary studies to create his own, invented composition: 'in the painting I let my own head, in the sense of *idea* or *imagination*, work, which isn't so much the case with *studies*, where no creative process *may* take place, but where one obtains *food* for one's imagination from reality so that it becomes right' [496]. This approach provided him not only with a technical foothold, but also the opportunity to emphasize his artistry, since working from the imagination was more highly esteemed than strictly adhering to reality. Hence his decision to compose his picture of 'the peasants around a dish of potatoes in the evening' in the academic manner – in the studio, based on studies he had drawn in the family's cottage [490].[16] Van Gogh arranged the figures in *The Potato Eaters* around a table, so that he would not have to paint each one from head to toe. It enabled him to position them more credibly than before within the composition.

22
Vincent van Gogh,
Four People Sharing a Meal, March–April 1885. Van Gogh Museum, Amsterdam

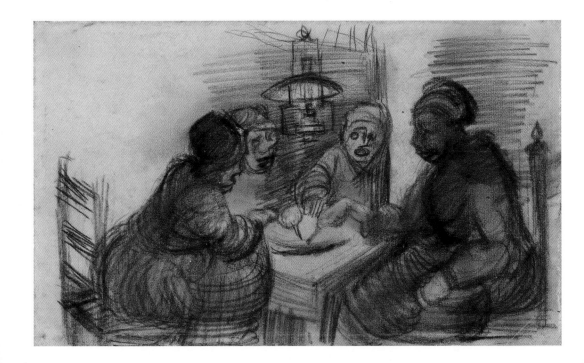

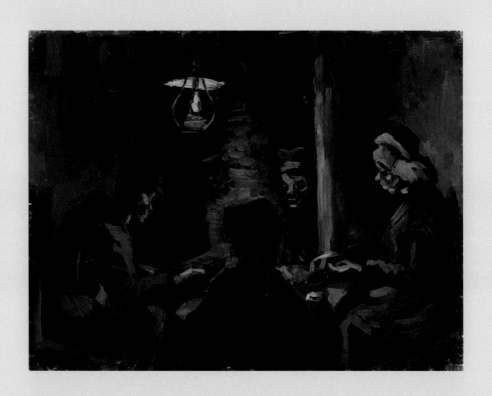

23
Vincent van Gogh,
*Study for 'The Potato
Eaters'*, April 1885.
Van Gogh Museum,
Amsterdam

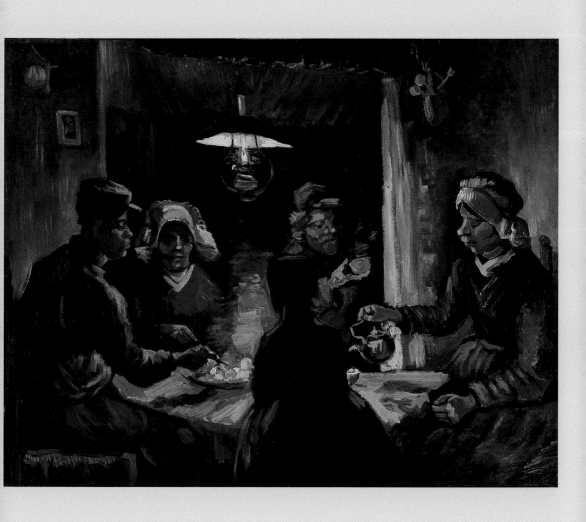

24

Vincent van Gogh,
The Potato Eaters,
April 1885.
Kröller-Müller
Museum, Otterlo

Waarde Theo,

Het heeft my eenigzins verwonderd nog niet eens een woordje van u ontvangen te hebben. Ge zult zeggen ge hadt het nu te druk daaraan te denken — en dat kan ik dan ook wel begrypen.

Het is reeds laat — maar ik wilde U nog eens zeggen dat ik regt hartelyk hoop dat voortaan de correspondentie weer wat levendiger zal worden dan ze den laatsten tyd wel was.

Hierby gaan twee krabbels naar een paar studies die ik maakte terwyl ik tevens bezig ben op nieuw aan die boeren om een schotel aardappels.

Ik kom er daarnet van thuis — en heb by het lamplicht nog gewerkt er aan — afschoon ik het by dag ditmaal heb aangezet.

Ziehier hoe de compositie nu geworden is Ik heb het op een vry groot doek geschilderd ~~en zooals~~ ~~dooles~~ en zooas de Schets nu is zit geloof ik er wel leven in.

25

Letter from Vincent
van Gogh to Theo
with sketch of *The
Potato Eaters* (recto),
9 April 1885.
Van Gogh Museum,
Amsterdam

26

(pp. 44–45)
Vincent van Gogh,
The Potato Eaters,
April–May 1885.
Van Gogh Museum,
Amsterdam

He began in the cottage with a drawn sketch (*croquis*) of four peasants around a table and then painted a small oil sketch (*ébauche*) – a swiftly executed composition, in which the figures are indicated with broad, fluent brushstrokes (figs. 22, 23). Van Gogh concentrated on expressing the light and shadow, and was less concerned with the figures or the space itself. The man on the left is reading, while the other three eat their supper. The woman in the middle seems to be kneeling at the table and is painted from the rear as a silhouette. This has the effect of a *repoussoir*, creating depth and giving the viewer a sense of being able to join them around the table.[17]

Van Gogh must have been pleased with the oil sketch, as it formed the basis for his second painted study (*étude*) (fig. 24). This time, he chose a canvas twice as large as that of the first oil sketch and strongly emphasized the light and shade effects, which seem less realistic as a consequence. While the details are worked out to a much greater extent in this second study, the brushwork is once again sketchy in character. The faces, for instance, are not fully developed. On 9 April, he made a pen-sketch of the second version in a letter to Theo, expressing his satisfaction: 'I believe there's life in it' [492] (fig. 25). A week later, around 18 April, he felt ready to paint *The Potato Eaters* in his studio (fig. 26).[18]

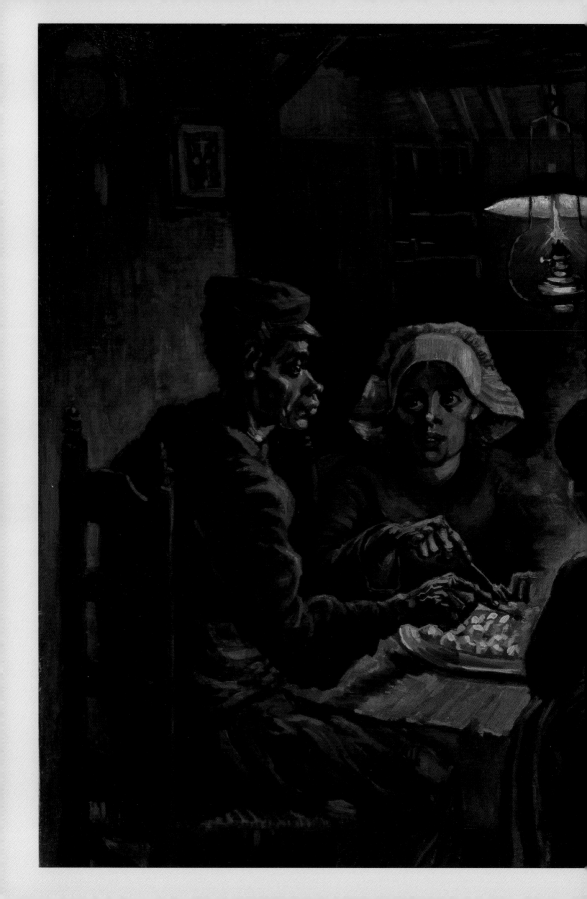

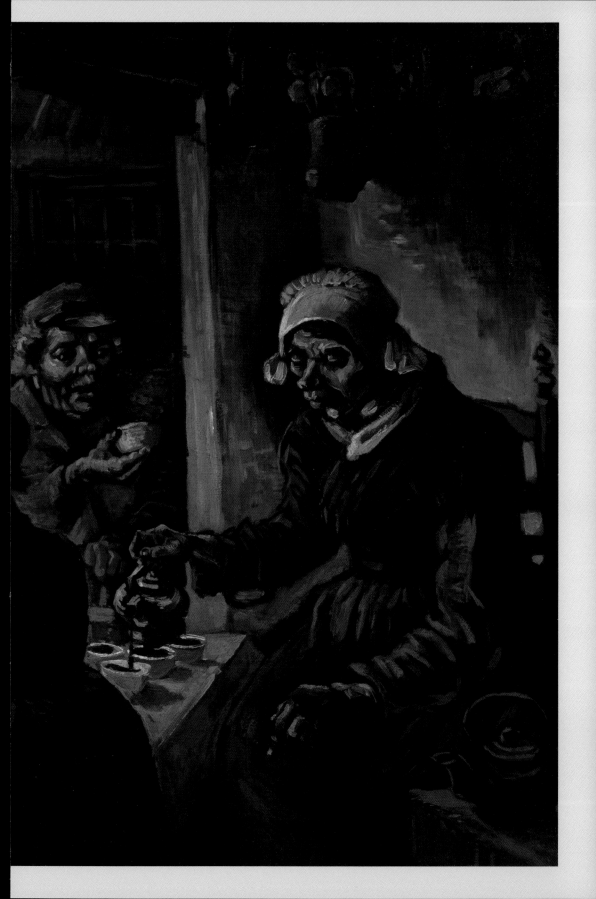

THE PAINTING

The meagre meal, consisting only of potatoes, is the central focus of the third and final version of *The Potato Eaters*. The older woman on the right pours coffee into the four cups on the table. She sits on a wooden chair pushed below the mantelpiece, with a second kettle next to her and the fire burning beyond the edge of the picture. A steel handle used to lift the hot kettle safely off the flames hangs around her right arm (fig. 28).[19] To the left of her, an older man holds out a fifth cup, the steam from which suggests it has just been filled with coffee. Van Gogh has not conveyed this very successfully, as the man's expectant pose suggests that his cup is actually still empty. In the middle of the foreground, we see a young girl with her back to us, strands of her short hair falling from beneath her bonnet. Her silhouette is surrounded by steam from the hot potatoes beneath the lamplight. A man and woman to her left use their forks to take a potato from the dish. She looks at her fellow diner, but he just stares blankly. The angled back of his chair closes the composition. Is this lack of interaction a problem of composition, attributable to Van Gogh's inexperience when it came to arranging groups? Or is it simply the reality of a hard day's work in the fields?

The small room in which the family sits around a table is divided by a large beam running across the ceiling. A pendulum clock showing seven in the evening hangs on the left wall alongside a framed colour print of the Crucifixion, a common blessing in Catholic homes at the time. A clog containing cutlery and a box of salt are mounted on the wall above the fireplace on the right, where sausages and a pig's bladder have also been hung up to dry (see pp. 48–49). Beyond the table, in the other part of the room, there is a box bed with curtains. The back wall has a door on the left and a large window with individual panes on the right.[20]

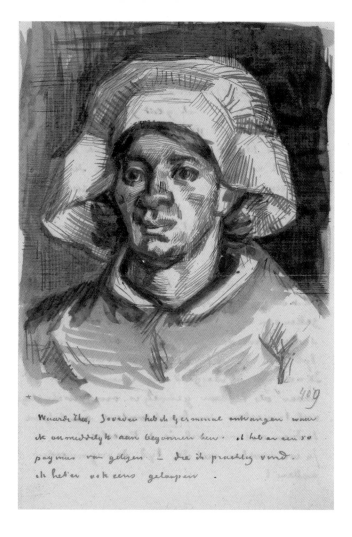

We can deduce from Van Gogh's letters that the woman sitting behind the table is Gordina de Groot, a peasant woman he had used as a model on previous occasions (fig. 27).[21] She appears to be the youngest of the four adults – her face as yet unmarked by life, in contrast to the deep wrinkles, pronounced cheekbones and sunken cheeks of the other three. And if this is Gordina, the other models for *The Potato Eaters* are also likely to have been members of the De Groot-van Rooij family, who lived in Nuenen at what is now number 4 Gerwenseweg in a basic dwelling consisting of two connected cottages with a double fireplace.[22]

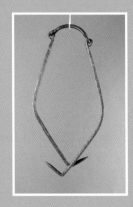

28
A three-part steel
handle was used in the
nineteenth century
to lift a hot kettle
safely off an open fire.
Noordbrabants Museum,
's-Hertogenbosch

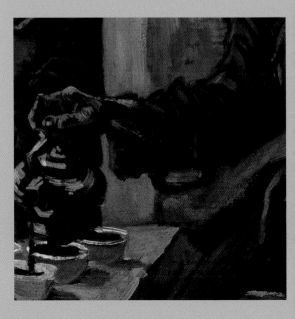

Details from *The Potato Eaters*: the clock, the print with the Crucifixion, the clog containing cutlery, the sausages hanging over the fireplace to dry and the steel handle.

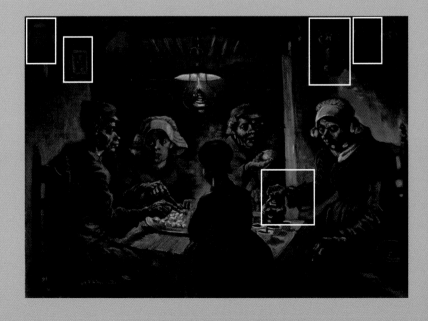

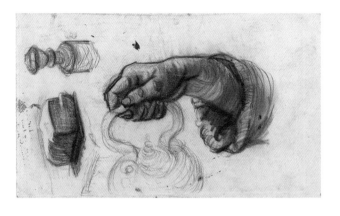

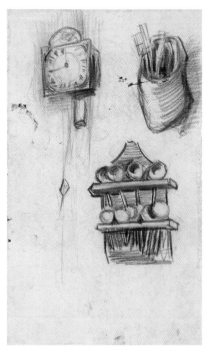

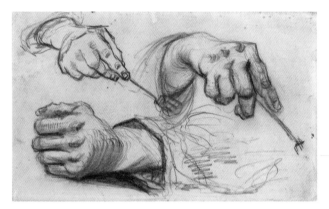

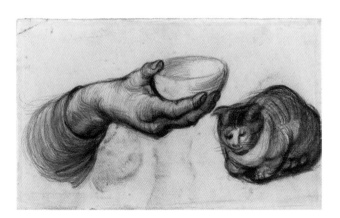

29

Vincent van Gogh, *Clock, Clog with Cutlery and a Spoon Rack*, April 1885. Van Gogh Museum, Amsterdam

30

Vincent van Gogh, *Hand with a Pot, the Knob of a Chair and a Hunk of Bread*, April 1885. Van Gogh Museum, Amsterdam

31

Vincent van Gogh, *Three Hands, Two Holding Forks*, April 1885. Van Gogh Museum, Amsterdam

32

Vincent van Gogh, *Hand with a Bowl, and a Cat*, April 1885. Van Gogh Museum, Amsterdam

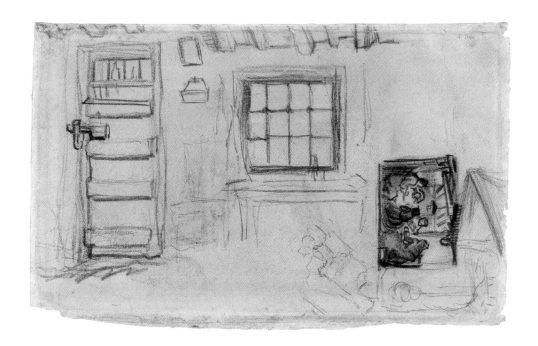

33

Vincent van Gogh,
*Studies of the Interior of
a Cottage, and a Sketch
of The Potato Eaters*,
April 1885. Van Gogh
Museum, Amsterdam

Van Gogh painted his two oil studies for *The Potato Eaters* in the family's home, as he wished to capture its sober interior. There were details, however, that he did not work up fully in his first two versions, and so he made further evening visits to the cottage 'to redraw sections on the spot' [496]. He clearly used several of these drawings for *The Potato Eaters* (figs. 29–33). The artist adjusted the perspective of the interior as he saw fit, pushing the two walls on either side of the table further into the picture. The side of the fireplace is positioned at an angle to the upper edge of the canvas, with small curtains attached to it, telling the attentive viewer where the limits of the room's side wall are located. This serves to emphasize the modest nature of the dwelling. The perspective is reminiscent of a fish-eye lens, the viewing angle of which is greater than 180°, allowing more to be shown than would be possible at a glance.[23] In his second version of the scene, Van Gogh replaced the kneeling woman in the first oil sketch with a standing girl, added a fifth

figure to her left and shifted the bowl of steaming potatoes in the same direction. The woman on the right, meanwhile, was now shown pouring coffee. The painting is livelier and more balanced as a result.

Potatoes and coffee might seem like a strange combination, but it is entirely possible that they were consumed at the same time at supper. Coffee quickly gained in popularity in the Netherlands when it began to be imported from the colonies in the seventeenth century. By the middle of the eighteenth it had become affordable to every layer of society, and soon displaced even beer and water as the most widely consumed beverage.[24] Rather than coffee, however, rural people customarily drank a substitute brewed from roasted chicory roots.

Van Gogh viewed *The Potato Eaters* as a symbol of genuine, unadulterated peasant life, which he believed to be far superior to and 'more honest' than the progress-fixated lives of the urban bourgeoisie. He was convinced that for all their hardships, rural people were more content than city dwellers, because the connection between human beings and nature had not yet been lost in the countryside.[25] His work thus had to be 'a REAL PEASANT PAINTING', rustic and authentic, in which technical excellence would actually be jarring. Van Gogh wanted people to 'get the idea that these folk, who are eating their potatoes by the light of their little lamp, have tilled the earth themselves with these hands they are putting in the dish, and so it speaks of MANUAL LABOUR and – that they have thus honestly *earned* their food' [497]. The painting should give people food for thought, not only in relation to art, but above all to life.[26]

A WHOLE WINTER OF PRACTICE

The emphasis in *The Potato Eaters* is on the hands and faces, which Van Gogh depicted from all sides – *en face, en trois-quarts* and *en profil* (see pp. 54–55).[27] He drew to this end on the experience he had gained during the winter: 'Although I'll have painted the actual painting in a relatively short time, and largely from memory, it's taken a whole winter of painting studies of heads and hands' [497] (figs. 34, 35). Despite having already painted two oil studies, he informed Theo at the end of April that he had made new studies of certain 'heads' and had been very occupied with the hands: all to introduce as much 'life' into

34

Vincent van Gogh,
*Head of a Young Man
with a Pipe*, December
1884–May 1885. Van
Gogh Museum,
Amsterdam

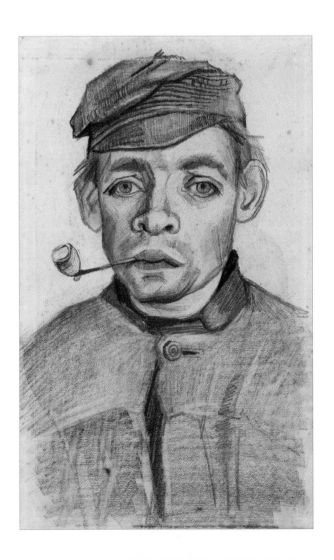

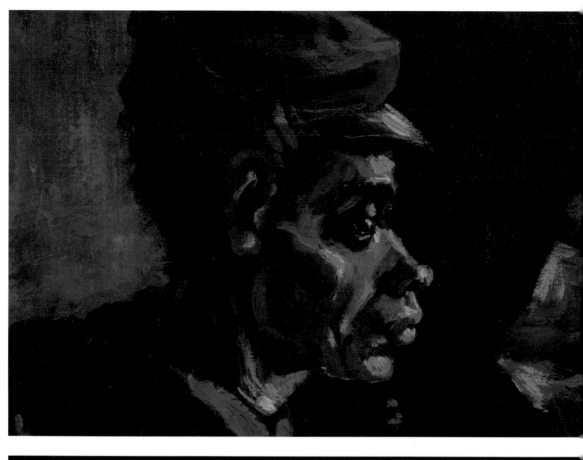
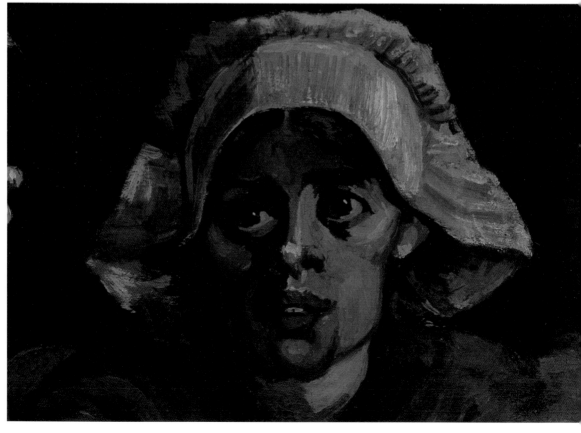

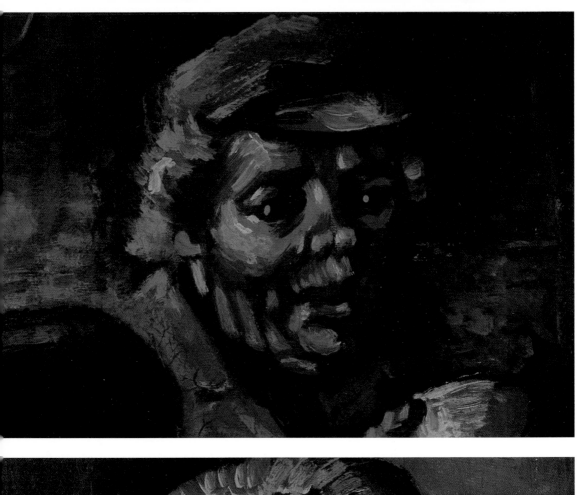

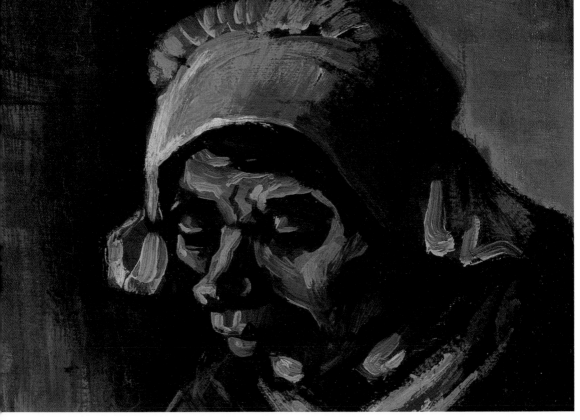

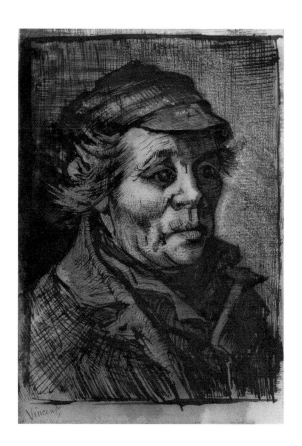

the work as possible [496]. While it is not clear precisely which studies he was alluding to, there are several possibilities, as the models they depict are the same people as in *The Potato Eaters* (figs. 36, 38, 39).

Van Gogh got the idea of painting studies of this kind in late 1884, when he and Van Rappard had 'visited people house by house' in Nuenen and had 'also discovered new models' [467]. He must have come across the models for his *Potato Eaters* in a similar way. In all, he painted over forty peasant heads. Van Gogh was less interested in true-to-life portraits as in 'types' representing a larger group (fig. 37). By working from nature and studying the same model repeatedly, he arrived at something that was 'different from an ordinary study, more true to type, that's to say: more felt' [437]. He wanted to paint

35

Vincent van Gogh,
Head of a Man,
December 1884–
January 1885. Van Gogh
Museum, Amsterdam

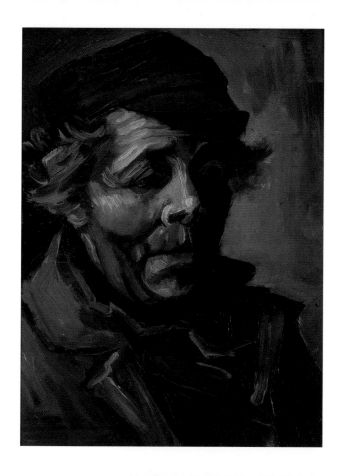

36

Vincent van Gogh,
Head of a Peasant,
December 1884. Art
Gallery of New South
Wales, Sydney

37

Vincent van Gogh,
Head of a Woman,
May 1885. Van Gogh
Museum, Amsterdam

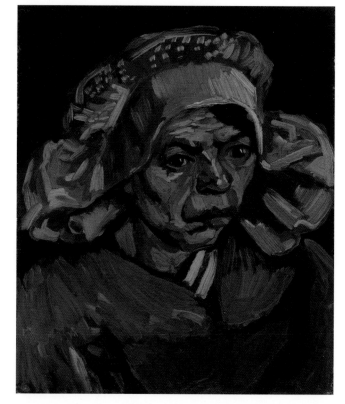

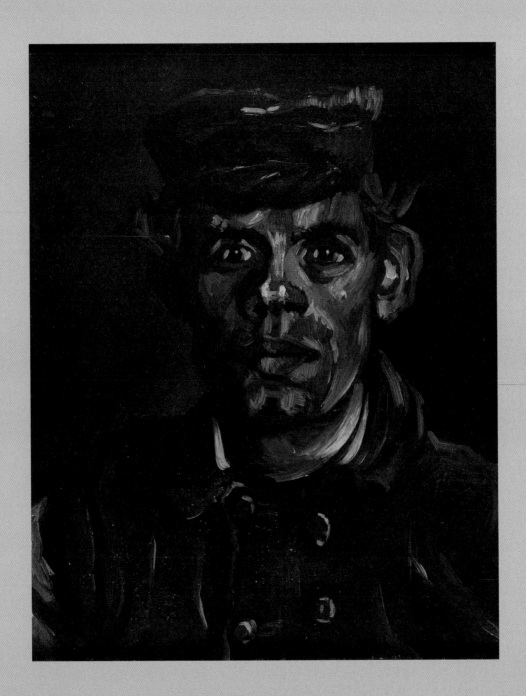

38

Vincent van Gogh,
Portrait of a Peasant,
March 1885. Royal
Museums of Fine Arts
of Belgium, Brussels

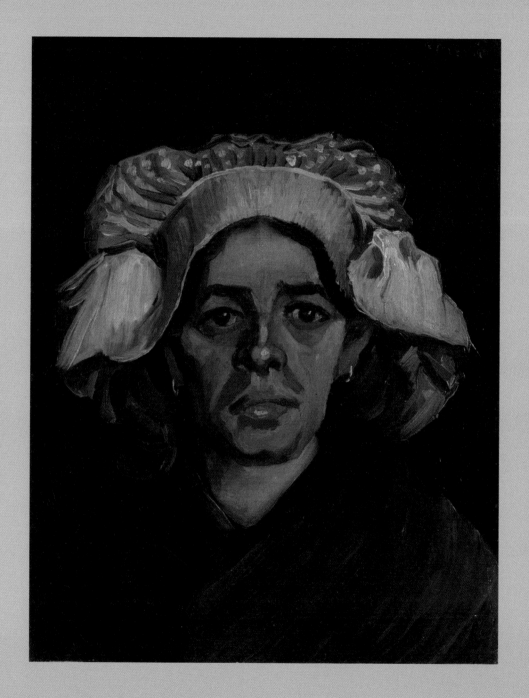

39

Vincent van Gogh,
Head of a Woman,
Gordina de Groot,
March 1885. Van Gogh
Museum, Amsterdam

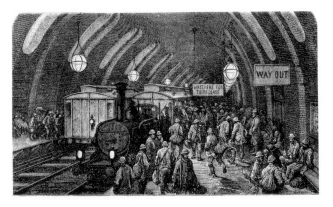

'the dead simple, most everyday things' and for the peasant faces 'to derive the subject from the characters themselves' [476, 477].

Van Gogh felt a natural affinity with poor, simple people rather than with the well-to-do middle class into which he himself had been born. He had a fondness as an artist for prints that depicted the harrowing reality of working-class life, such as those by Gustave Doré in *London: A Pilgrimage* or Charles Paul Renouard's *The Industrial Crisis in Lyon,* published in the French magazine *L'Illustration,* as well as the prints in magazines like *The Graphic* and *The Illustrated London News*. The artist built up his own well-stocked collection of illustrations of this kind (figs. 40, 41).[28] The theme Van Gogh chose for *The Potato Eaters* is in keeping with this interest and he also drew inspiration for his series of peasant heads from the British magazine *The Graphic,* in which artists

40

Clément (Edouard) Bellenger after Charles Paul Renouard, 'The industrial crisis in Lyon – Out of work', in *L'Illustration. Journal Universel* 84 (25 October 1884), p. 268

41

After Gustave Doré, 'An underground railway in London', in *De Katholieke Illustratie* 10 (1876–1877), p. 141

42

Vincent van Gogh,
Head of a Woman,
November
1884–January 1885.
Van Gogh Museum,
Amsterdam

had published black-and-white working-class portraits titled 'Heads of the People' [476].[29] The rural workers of Nuenen provided suitable models for him to improve his technical understanding of colour, light and composition, prompting him to write admiringly about 'the heads of these women here with the white caps – it's difficult – but it's so eternally beautiful. It's precisely the chiaroscuro – the white and the part of the face in shadow, that has such a fine tone' [478] (fig. 42).

PHYSIOGNOMY

The people depicted in *The Potato Eaters* have rough, weather-beaten faces and large, bony hands – Van Gogh's means of emphasizing that these are hard-working rural labourers. He wanted '**to paint them in their coarseness**' rather than sentimentalizing peasant life as was customary in painting at the time [497]. He looked for models '**of precisely the type I have in mind (coarse, flat faces with low foreheads and thick lips, not that sharp look, but full and Millet-like)**' [451] (fig. 43). Van Gogh's notions of certain 'types' are linked to physiognomy, a pseudo-science considered valid at the time, according to which an individual's personality and character could be deduced from his or her appearance. Such ideas are rejected nowadays, but were widely shared in the nineteenth century. In 1880, Van Gogh read an extract by Alexandre Ysabeau in Johann Caspar Lavater and Franz Joseph Gall's textbook on the subject: *Physiognomonie et phrénologie, rendues intelligibles pour tout le monde* (1862). Although physiognomy and phrenology have long been discredited, Van Gogh found beauty in 'authentic types', which he glorified by choosing 'ugliness' over characterless faces.

The painter's views on physiognomy also led him to associate certain faces or features with animals. In December 1882, for instance, he described a drawing of a sower as '**a sort of cockerel type: a shaven face, fairly sharp nose and chin, the eye small, mouth sunken**' [291]. He later spoke of ministers with '**pig faces**' [395]. Van Gogh had read in the biography of Millet that the French painter sought to give his peasants an expression suggesting that human beings are not necessarily that superior to animals.[30] The artist's description of people in terms of animals and his search for authentic types does not mean, however, that he had no respect for country folk. On the contrary, he

Vincent van Gogh,
Head of a Woman,
December 1884–May
1885. Van Gogh
Museum, Amsterdam

greatly admired the way they lived. Yet even though he believed he
had inserted himself in the heart of peasant life, he would always be
the parson's son and an artist – an outsider observing their world from
his own perspective.

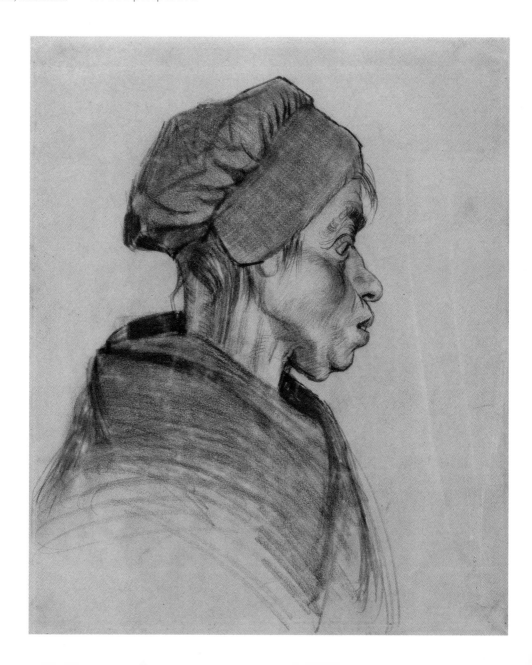

COLOUR VERSUS LIGHT AND SHADE

What drew Van Gogh to the cottage in the evening was his desire to capture effects of light and shade, also known as 'chiaroscuro'. He had been adept at suggesting such effects in his drawings for a few years by then and he now made several small studies of 'figures against the light from a window' to enable him to apply them to his paintings too [485] (fig. 44). Although he made frequent use of back-lighting when posing his models, he opted to light *The Potato Eaters* in a different way, namely 'in the evening by lamplight in the cottages' [484]. The previous year, he had often chosen weavers as subjects, observing them at work in the evenings in their lamp-lit homes. It both fascinated him and reminded him of the twilight effects in the work of Rembrandt van Rijn (1606–1669), which he knew well from his visits to the Rijksmuseum in Amsterdam or, for example, from the print after Millet's painting *Evening* (1873).[31]

The evening effect in *The Potato Eaters* is created by an oil lamp hanging centrally above the table (fig. 45), its bright orange flame the most intense colour on the canvas. The fireplace must also have been an important source of light, but Van Gogh deliberately left it beyond the edge of the picture to focus all the viewer's attention on

44

Vincent van Gogh, *Woman Sewing*, March–April 1885. Van Gogh Museum, Amsterdam

45

Oil lamp of a similar type to the one in *The Potato Eaters*. Noordbrabants Museum, 's-Hertogenbosch

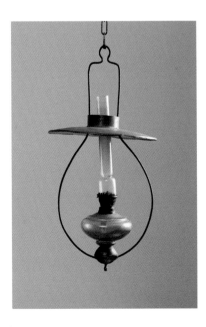

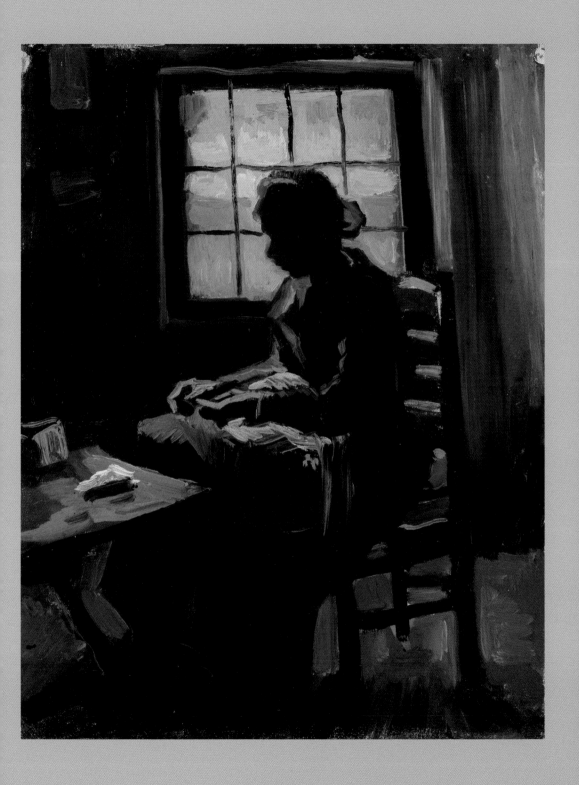

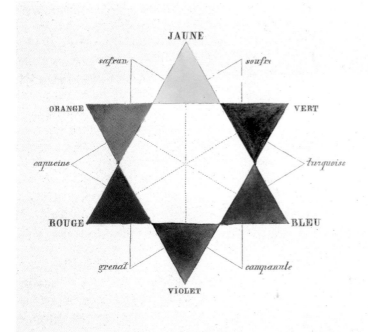

JAUNE

safran | soufre

ORANGE | VERT

capucine | turquoise

ROUGE | BLEU

grenat | campanule

VIOLET

the lamp. To achieve this lighting effect, he drew on the knowledge he had gained about the operation of colour. Van Gogh's relentless focus on improving his painting technique had received an additional boost in the spring of 1884, when Van Rappard sent him a number of theoretical texts, including *Les artistes de mon temps* (1876) by the French art theorist Charles Blanc, in which he read about 'the law of simultaneous colour contrasts' and 'broken tones'.[32] According to this law, two complementary colours (those from opposite sides of the colour wheel: red-green, blue-orange and yellow-purple) intensify each other when placed together (fig. 46). 'One only has to add a very little bit of yellow to a colour to make it appear *very* yellow, if one puts that colour into or next to a violet or lilac tone', Van Gogh enthused to Theo [449]. He experimented in portraits and still lifes with 'bright red' alongside 'pale green' [489] (figs. 47, 48).

Broken tones are created when two complementary colours are mixed. An equal mixture produces a neutral shade, while unequal mixing

46

Colour wheel showing complementary colours, from: Charles Blanc, *Grammaire des arts et du dessin: architecture, sculpture, peinture*, Paris 1883

47

Vincent van Gogh, *Head of a Woman*, May 1885. Van Gogh Museum, Amsterdam

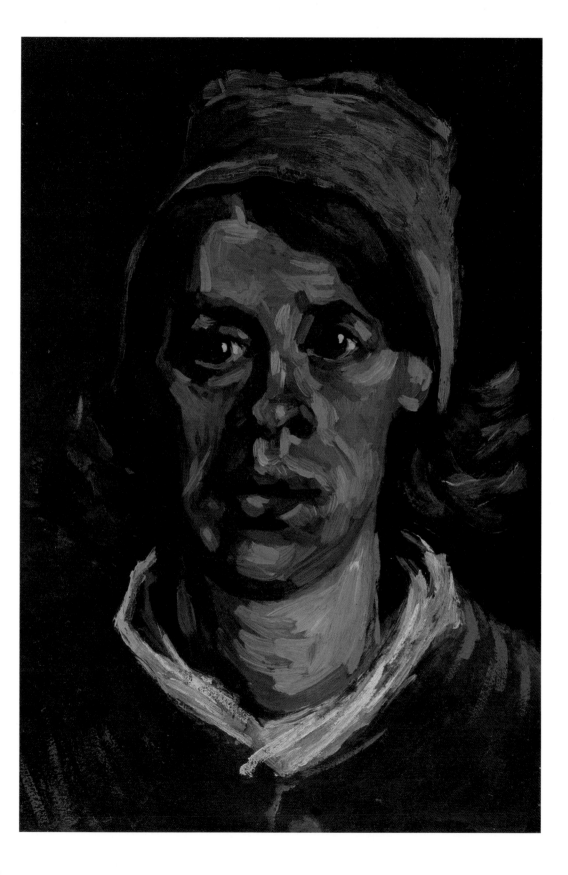

results in a shade of brown tinged with whichever of the two colours is dominant: red-brown or yellow-brown, for instance. Two broken tones placed together attenuate one another, while a broken tone (red-brown) paired with a whole tone (red) intensifies them both. These theories played a decisive role in Van Gogh's choice of colour in *The Potato Eaters*.

Blanc also wrote about the use of 'couleur locale', stating that since the effect created by a colour depends on the colours that surround it on the canvas, it is not necessary to choose one that matches the observed reality in order to create a realistic representation. Van Gogh discovered that he could use a dark colour to paint a light element, provided that the surrounding colours were darker still. As he himself put it: 'one has a *dark* colour that can seem *light*. (or rather *appear to be*)' [449] (figs. 49, 50).

48
Vincent van Gogh, *Still Life with Vegetables and Fruit*, autumn 1884. Van Gogh Museum, Amsterdam

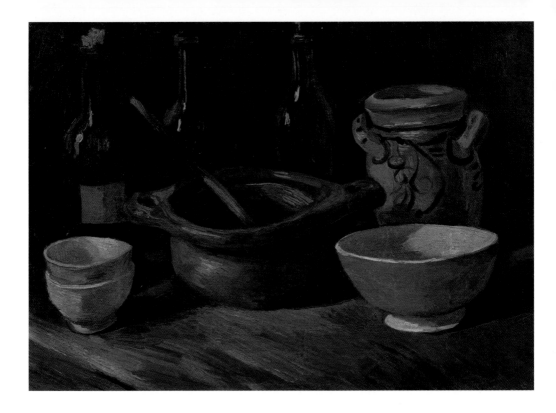

49

Vincent van Gogh,
*Still Life with
Earthenware and
Bottles*, September–
October 1885. Van
Gogh Museum,
Amsterdam

In the case of *The Potato Eaters*, it was all about 'the painting of DARKNESS that is still COLOUR' [495]. To achieve this effect, he used barely any white paint in the white areas, but a neutral dark-grey colour that he obtained by mixing red, blue and yellow: 'The subject here is a grey interior, lit by a small lamp. The drab linen tablecloth, the smoke-stained wall, the dusty caps in which the women have worked on the land – all these, *when you look at them through your eyelashes*, prove to be *very dark grey* in the light of the lamp, and the lamp, although being a red gold glow, is even lighter – and by a long way – than that white' [499].

For the flesh tones of the heads, he initially used a mixture of yellow-ochre, red-ochre and white, among others, but this 'certainly didn't do': the effect was far too light relative to the rest of the painting. He decided to repaint them in dark-copper and 'soapy' green tones,

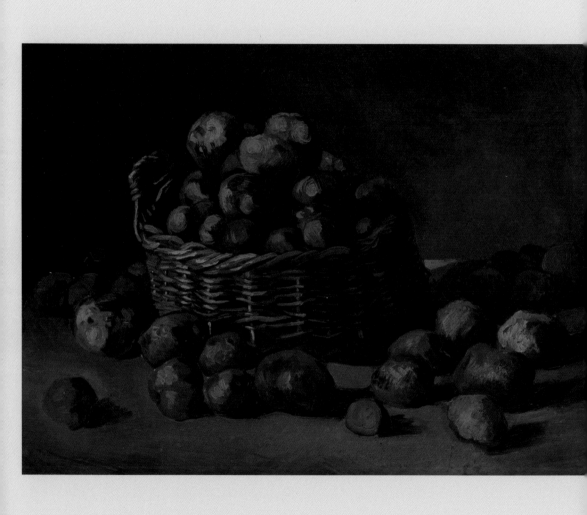

'something like the colour of a really dusty potato, unpeeled of course'. While doing so, he was put in mind of Millet, about whom it had 'so rightly been said': *'His peasants seem to have been painted with the soil they sow'* [499, 506].

Van Gogh had not realized that as far as the modern Parisian art market was concerned his chosen palette was out of date. He had barely heard of the Impressionists and showed little curiosity about their work. Vincent struggled to comprehend why Theo was so captivated by their light touch and bright colours: 'There's a school – I believe – of – Impressionists. But I don't know much about it. I do know, though, who the original and actual people are around whom – as around an axle – the peasant and landscape painters will revolve. Delacroix, Millet, Corot and the rest' [495]. Only in 1886, when Van Gogh saw the work of the Impressionists in Paris with his own eyes, did he change his tune. He began to realize what adjustments he would have to make to his brushwork and colour to keep up with the innovations that had seized the market for 'modern', contemporary art. In Nuenen, however, all that was still some way off.

The most difficult things to paint well were the heads, hands and the interaction between the figures – the ensemble. Because of this, Van Gogh was still hard at work at the end of April, two weeks after starting *The Potato Eaters*. Worried that he risked overworking the canvas, he took it to his friend and amateur painter Anton Kerssemakers (1846–1924) in Eindhoven, where he completed the final details over several days before coating the canvas with a thin layer of coloured resin varnish, as was customary at the time. According to Van Gogh, Kerssemakers was enthusiastic about his use of colour and the accomplished peasant heads and hands. Despite his concerns about ruining the painting, Vincent wrote around 2 May that he had taken it to the De Groot-van Rooij's cottage to make the very last adjustments.[33] It was a long time before he considered his painting – on which he had worked for two and a half weeks – to be complete. 'I believe I'll finish

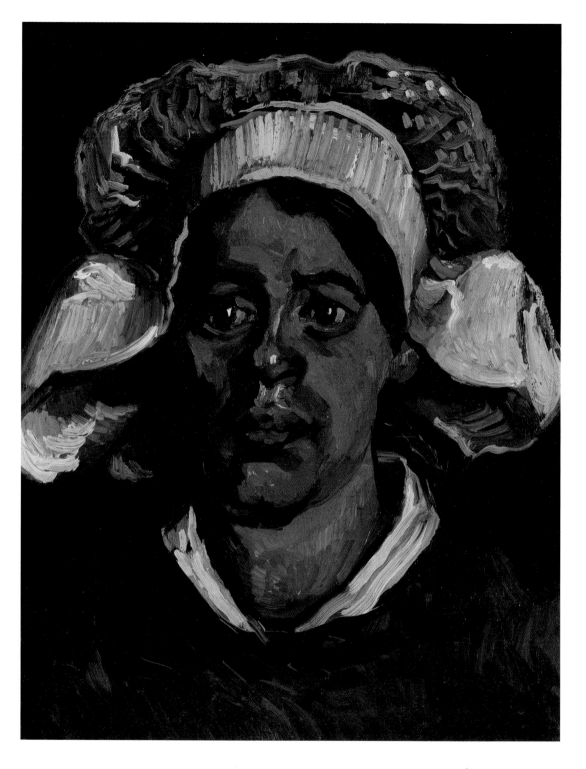

51

Vincent van Gogh,
Head of a Woman
Wearing a White Cap,
November 1884–May
1885. Kröller-Müller
Museum, Otterlo

it though – in a manner of speaking – for I myself will actually never think my own work finished or ready' [499].[34]

He finally completed *The Potato Eaters* on 5 May and signed the work 'Vincent' on the back of the chair on the left, placing his name on the crosspiece at the top. The following day, he packed the barely dry canvas in a flat crate and sent it off to Paris, having assured Theo that he would not do so 'unless *I know for sure* that it's *something*' [496]. To add weight to his painting and to highlight his academic working method, he had previously dispatched painted studies of peasant heads, including two portraits of Gordina de Groot and the first oil sketch (figs. 23, 51, 52). He apparently decided to keep hold of the second painted version (fig. 24).[35]

52

Vincent van Gogh, *The Head of a Peasant Woman*, 1885. National Galleries of Scotland, Edinburgh

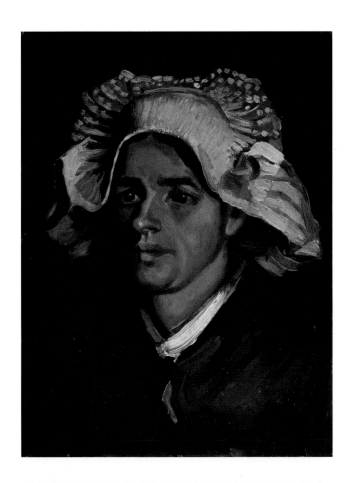

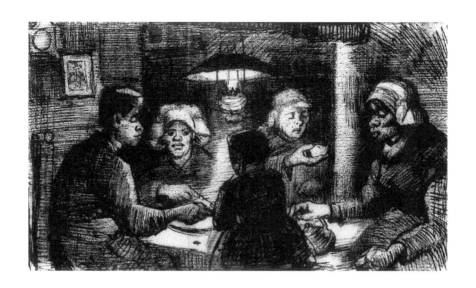

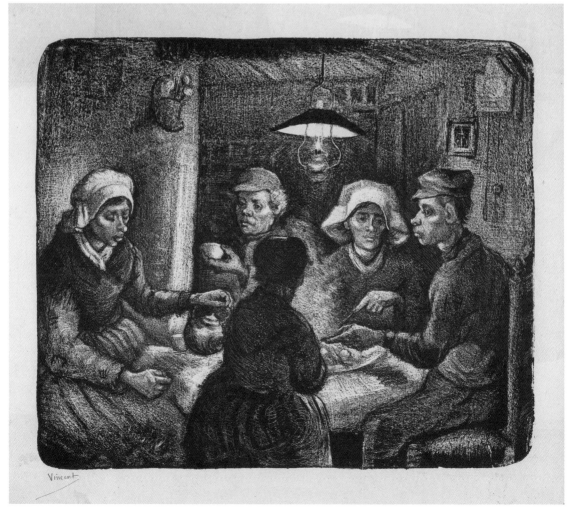

ON THE MARKET

Van Gogh began to market his painting before even putting brush to canvas. He wrote to Theo on 9 April, recommending that his brother contact someone at *Le Chat Noir* – a satirical publication associated with the Paris nightclub of the same name. The magazine was devoted to modern art and literature and Van Gogh thought there might be an opportunity to get 'a scratch of those potato eaters' published [492]. On 13 April, he sent Theo a loose sheet with a drawn sketch of his second oil study to show the editors of *Le Chat Noir* by way of example (fig. 53). Theo took it to the artist Henri Pille, who worked for the magazine, but he showed no interest. The renowned art dealer Paul Durand-Ruel, who made his name selling works by the Barbizon painters, saw little to recommend it either, but the smaller dealer Alphonse Portier thought the work had character.[36] Vincent hoped Portier would be willing to exhibit his work, but was well aware that it remained to be seen whether he would have a similarly positive opinion of his yet-to-be-completed *Potato Eaters*. His efforts were not limited to Paris: the art dealer E.J. van Wisselingh, who was based in The Hague at the time, also received several painted heads and a copy of the lithograph, but does not seem to have been impressed. A little while later, Van Gogh also enquired about the possibility of approaching the English dealer Thomas Wallis in London, but this too came to nothing.[37]

In addition to the sketch, Van Gogh made a lithograph after his second oil study, for which he had ordered a stone from Gestel printers in Eindhoven (fig. 54).[38] He told Theo that the print would not interfere with the sketch for *Le Chat Noir*, since it was a private edition. The fact that Van Gogh had different contacts in mind and even chose two different media – drawing and lithography – to generate attention for his painting illustrates how carefully he weighed his interests.[39]

He asked his brother to give the lithograph to Portier – as many copies as he wanted – along with the accompanying letter he had enclosed. It seems to have been a lengthy missive, as he warned Theo that it would appear 'rather long and consequently impractical', but that a more concise explanation would not do his work justice. Vincent wanted to make clear to the dealer that he had not painted the work in the Impressionist manner, but in that of 'old people' like Delacroix, Millet and Corot, and to persuade him of the correctness of his chosen path. According to Van Gogh, the dark palette he had adopted for his work was in fact typical of his century's painters, thereby disregarding the new generation of Impressionists and Neo-Impressionists [495]. Portier disappointed him by not putting either the drawing or the lithograph on display. Despite this setback, Van Gogh still intended to send him *The Potato Eaters*, on condition that he exhibited it at his gallery.[40]

Theo thought the lithograph was too 'woolly', but Van Gogh put this down to his limited technical mastery of working directly on the stone (despite his experience with transfer lithographs) and explained that he had not left enough white in the first instance to print properly [499]. He planned to make a second version of the lithograph as soon as *The Potato Eaters* was finished, and this time he would correct his elementary mistake – he had copied the work onto the stone exactly, which meant the composition was reversed in the print. However, his eagerness to send *The Potato Eaters* to Paris meant he never had time to make the second lithograph.[41]

Van Gogh hoped that art lovers would appreciate his painting. He had already described the success he wanted to achieve at the beginning of the project, if he were able to produce things 'as they come straight from the cottages. Of course people will say they're not finished or they're ugly &c. &c., but – in my view – *show them anyway*. For my part, I have a firm belief that there are a few people who, ending up in and tied to the city, retain indelible impressions of the country, and continue to feel homesick for the fields and the

peasants all their lives. Art lovers like this are sometimes struck by sincerity, and not put off by what deters others. [...] We're now at the beginning of letting people see; I believe absolutely and utterly that little by little we'll find a few people for it.' This reflects Van Gogh's conviction that 'painting is *a faith* and that it brings with it *the duty* to pay no heed to public opinion – and that in it one conquers by *perseverance* and not by *giving in*' [490].

Although Van Gogh had confidence in his painting, he was also uncertain about it. He was aware that *The Potato Eaters* was not in keeping with the customary aesthetics of the time. The realistic work of contemporaries such as Israëls, Degroux and Van Rappard frequently contained an element of Romanticism, yet this was entirely lacking in Van Gogh's work, and his palette was grey and monotonous compared to that of his colleagues. He became increasingly aware that the response would be negative, and predicted to Theo that people in Paris would cry 'QUELLE CROÛTE!' ('what a daub!') when they saw it [497]. All the same, he believed he would succeed in what he considered most important: '**giving a felt impression**' of what he had observed [492]. He sought to head off possible criticism: paintings like his that adhered very closely to reality were not always understood by critics, as such people were not familiar with nature or the sentiment being expressed. What was important to him was not producing a technically perfect painting, but conveying feeling and character: '**Yet there's a** certain *life* in it, and perhaps more than in certain paintings in which there are no errors at all' [494].

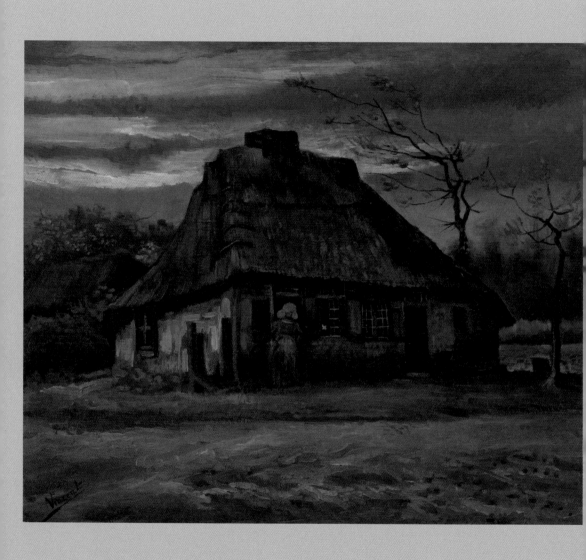

PRESENTATION

As *The Potato Eaters* neared completion, Van Gogh began to think about how to present the painting – a not insignificant factor that could contribute to its success or otherwise. He told Theo that the work ought best to be displayed 'against a tone like gold or copper' by 'holding a piece of paper in, say, an ochre colour behind it' [501]. If that were not available, a wall papered in yellow – 'a deep tone of ripe wheat' – would also suffice [497]. A gilt frame was another possibility he suggested. A pale background would certainly not benefit his work, which consisted of greys and dark tones. Gold or deep yellow tones would intensify the ensemble or, as Van Gogh put it, 'throw the whole thing backwards', by which he meant that the sense of space in the painting would be increased [497]. He went on to write that the shadows he had painted in blue would be complemented by a gold colour and would thus stand out better.

Van Gogh continued to look for ways to add weight to the painting after it had been sent to Paris. On 9 June, he sent two important works to Theo, which can be viewed as a continuation of the ideas he had first developed for a marketable painting in *The Potato Eaters*. He gave the new paintings French titles – *'La chaumière'* ('The Cottage') and *'Cimetière des paysans'* ('Peasants' Churchyard') – indicating that he wanted to sell these works too in Paris.

The Cottage offers an idyllic picture of peasant life with its view of the right-hand side of the De Groots' home, with a red evening sky and lamplight at the window (fig. 55). He wistfully compared the cosy cottages in Nuenen with birds' nests – sometimes more specifically 'a wren's nest' or *'people's nests'* [507]. This particular cottage consisted of two peasant dwellings under a thatched roof with a shared chimney: 'The thing struck me greatly; those two cottages, half decayed under one and the same thatched roof, reminded me of a couple of

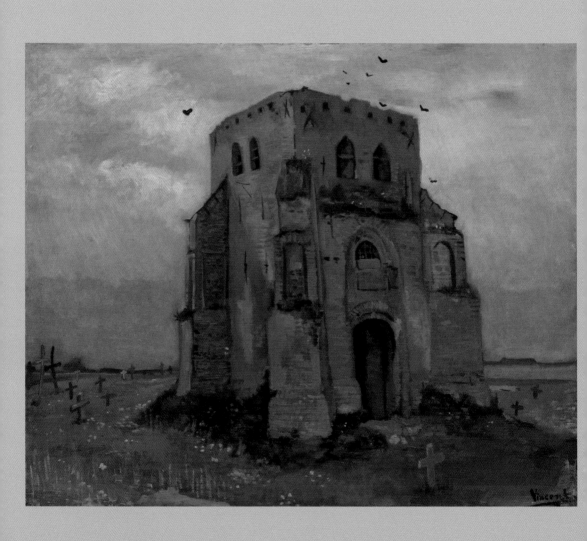

56

Vincent van Gogh,
*The Old Church Tower
at Nuenen ('The
Peasants' Churchyard'),*
May–June 1885.
Van Gogh Museum,
Amsterdam

worn-out old folk who make up just one single being and whom one sees supporting each other' [506].

The old fifteenth-century church tower was about to be demolished when Van Gogh decided to paint it shortly after completing *The Cottage* – 'The spire's already off', he told Theo [506] (fig. 56). The work was more than just a painterly motif: 'I wanted to say how this ruin shows that *for centuries* the peasants have been laid to rest there in the very fields that they grubbed up in life – [...] how, though, the life and death of the peasants is and will always be the same, springing up and withering regularly like the grass and the flowers that grow there in that churchyard' [507]. Peasant life to Van Gogh was linked to the eternal cycle of nature, and the three paintings together – *The Potato Eaters*, *The Cottage* and *The Old Church Tower* – told the story of life in the countryside, in which the peasants who work the land for their food are eventually buried in the same soil.

END OF THE DREAM

Two weeks after dispatching *The Potato Eaters* to Paris, Van Gogh wrote a letter to Theo from which we can infer how he had reacted. His brother thought that the figures were less successful than the faces – a fact that Vincent acknowledged. 'What you say about the figures is true, that as figures they aren't like the heads are. I've therefore thought about starting it very differently, that is tackling it from the *torsos* instead of from the *heads*. But then it would have become something *altogether* different.' Once again, however, he defended himself: 'As to sitting, though, don't forget that these people certainly don't sit on chairs like in one of Duval's cafés, say. [...] But anyway, it's simply painted the way it's painted' [502].

The criticism he received from Van Rappard, to whom he had sent a copy of the lithograph, was downright merciless. Vincent's artist-friend was shocked, he wrote, that his comrade had produced such a poor work. 'You can do better than this – fortunately; but why, then, observe and treat everything so superficially? Why not study the movements?' Such work was surely not intended seriously? 'That coquettish little hand of that woman at the back, how untrue! And what connection is there between the coffeepot, the table and the hand lying on top of the handle? What's that pot doing, for that matter; it isn't standing, it isn't being held, but what then? And why may that man on the right not have a knee or a belly or lungs? Or are they in his back? And why must his arm be a metre too short? And why must he lack half of his nose? And why must the woman on the left have a sort of little pipe stem with a cube on it for a nose? And with such a manner of working you dare to invoke the names of Millet and Breton? Come on! Art is too important, it seems to me, to be treated so cavalierly' [503].

Van Gogh was so outraged and wounded by this unkind commentary that he sent Van Rappard's letter back with a short covering

note, effectively putting an end to their friendship. A few more letters followed, but the two artists ceased to correspond with each other entirely after the summer of 1885. Van Gogh was disappointed that his friend, who knew him so well and with whom he had often worked side by side, should write to him in such a tone, but he was especially offended by Van Rappard's accusation that he had not wanted to paint the figures academically correctly. He wrote to Theo: 'And what I'm trying to get with it is *to be able to draw not a hand but* THE GESTURE, not a mathematically correct head but the overall *expression*. The sniffing of the wind when a digger looks up, say, or speaking. Life, in short' [502].[42]

In the meantime, Theo did his best to find a dealer for the unconventional work, but doubted that he would be able to do anything with it. Portier and the painter Charles Emmanuel Serret had also seen *The Potato Eaters* at the beginning of June and were highly critical of the depiction of the torsos and the dark colour scheme. Theo wrote to his mother too about his efforts to find dealers for Vincent's work and was clearly doing his utmost to achieve something with the painting on which his brother had pinned so many hopes. 'I showed his work to an old painter (his name is Serret), who saw and experienced a great deal in his life and besides has a good heart and a clear head.'[43]

The painting never featured in an exhibition and ended up hanging unsold above the mantelpiece in Theo's apartment in Paris. So ended Vincent's dream of exhibiting his first attempt at a masterwork at a leading Paris art dealer and winning recognition as a painter.[44]

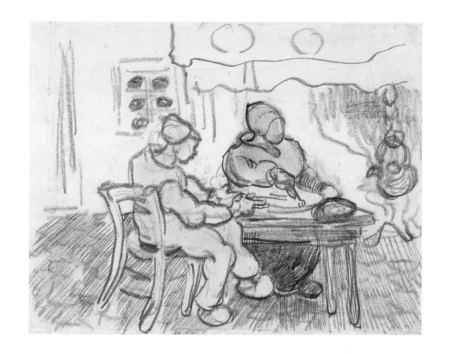

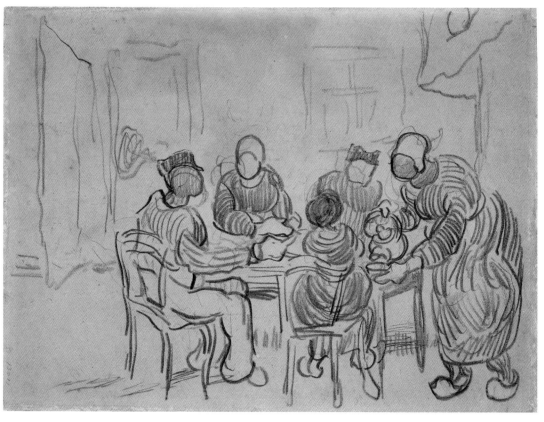

HOMESICK FOR 'THE NORTH'

57

Vincent van Gogh,
*Interior with Two
Figures Eating*,
March–April 1890.
Van Gogh Museum,
Amsterdam

58

Vincent van Gogh,
*Interior with Five
Figures Around a Table*,
March–April 1890.
Van Gogh Museum,
Amsterdam

Five years later, after persistent mental problems led him to have himself voluntarily admitted to an asylum in Saint-Rémy-de-Provence in May 1889, Van Gogh thought about repainting his three most important paintings from Nuenen: *The Potato Eaters*, *The Old Church Tower* and *The Cottage*. As he struggled with repeated breakdowns, his thoughts turned to 'the North', his native region, which he had not visited since 1885.[45] At the end of April 1890, he asked his mother and Theo to send him drawings of farmers from Nuenen, so that he could start working based on his earlier work: 'Please send me what you can find of *figures* among my old drawings, I'm thinking of redoing the painting of the peasants eating supper, lamplight effect. That canvas must be completely dark now, perhaps I could redo it entirely from memory. [...] Then if you like I'll redo the old tower at Nuenen and the cottage. I think that if you still have them I could now make something better of them from memory' [863].

He never got round to a new version of *The Potato Eaters*, but he did make several drawings of peasant figures eating a meal in an interior. The figures are set down in rounded contours with smaller areas filled with repetitive, curved, hatched lines – a style typical of Van Gogh at the time. The drawings do not have the cramped, oppressive perspective of the painting, but are viewed from more of a distance, so that the bodies of the figures are depicted better (fig. 57). Closest to *The Potato Eaters*, which was etched in Van Gogh's memory, is a drawing with five figures. But elements from the painting can also be found in the other variations, including a figure sticking a fork into the food on a dish, a steaming plate in the middle of the table and a kettle from which coffee is being poured (fig. 58). He seems to have worked the same way in Saint-Rémy as he had in Nuenen, making drawn studies of various compositions to prepare for the planned painting.[46]

59

Vincent van Gogh,
Evening (after Millet),
October–November
1889. Van Gogh
Museum, Amsterdam

After Vincent's death in July 1890, followed by Theo's six months later in early 1891, *The Potato Eaters* moved back to the Netherlands with Theo's widow, Jo Bonger, and their son Vincent, his artist-uncle's namesake. Jo rented a villa in Bussum and hung the painting above the mantelpiece, the same position as in the apartment in Paris.[47] She maintained the tradition in her subsequent homes too.[48] The painting was never sold and remained in the family collection, which has been on permanent public display at the Van Gogh Museum in Amsterdam since 1973.[49]

Van Gogh's French artist-friend Emile Bernard (1868–1941) was one of the first to write about *The Potato Eaters* after Vincent's death. The work was, he said, both 'exceptionally ugly and frighteningly lifelike'.[50] Others too were struck by the 'ugliness' emanating from the work, among them the art lecturer and Van Gogh admirer Henk Bremmer in 1911: 'neither Millet nor Israëls, nor yet even Zola, expressed the ugliness of such a figure in so matter-of-fact a way.'[51] Writing in that same year, the author and art critic Just Havelaar did not mince his words: 'hideous peasant portraits, ugly and unpleasant – unpleasant to the point of bestiality.'[52] He returned to the subject just over ten years later, following Jo Bonger's publication of Van Gogh's letters in 1914, writing on this occasion: 'when Van Gogh depicts the brutishness of his Brabant peasants, he is able through the power of his emotion to elevate the gruesome to a dark beauty, so that we always sense the great and noble human being behind the coarseness of his creation.'[53] Thanks to the letters, everyone could now discover the ambitions and significance behind this first attempt at a masterwork. So it was that Havelaar finally understood Van Gogh and acknowledged the artist's genuine admiration for peasant life.

Jo Bonger's conversations with Theo and the brothers' correspondence in her possession meant that she understood the special significance of *The Potato Eaters* better than anyone. From the very first Van Gogh exhibitions onwards, she always endeavoured to have the work included – sometimes as the only one from his Dutch period. Since then, *The Potato Eaters* has become a worldwide icon and the masterpiece has hung in exhibitions all over the world, from Tokyo to New York and from Paris to Stockholm, but also in the town hall in Nuenen.

As Van Gogh himself had pointed out, it was the message that mattered, the execution less so. The essential element was a life that was real, honest and industrious, but also 'old-fashioned' – an existence simpler than that of himself and of the many others who had been swallowed up by modern life in the city. Only in these terms can we understand why Van Gogh remained so committed to *The Potato Eaters* despite his own stylistic development, and why he never felt any critical reservations later. Almost a century and a half on, the painting's message remains as tangible as ever. Van Gogh's raw and truthful depiction of these five people and the rural life they symbolize can still overwhelm us today.

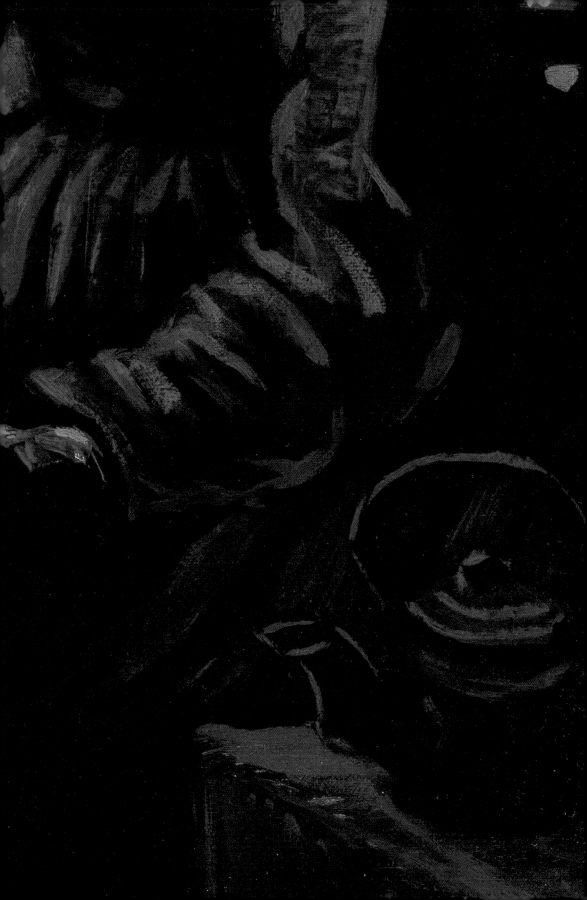

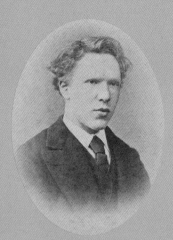

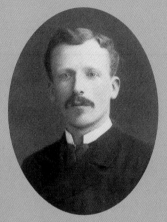

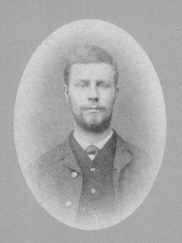

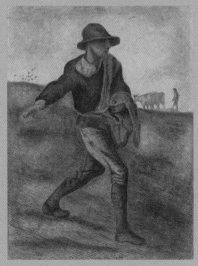

from left to right,
top to bottom:

Vincent van Gogh

The house in Zundert where
Vincent van Gogh was born, 1902

Theo van Gogh

Interior of the Goupil & Cie
gallery in The Hague

Anthon van Rappard

The Sower (after Millet),
Etten, 1881

Timeline

1853

Vincent van Gogh is born on 30 March in Zundert in the Dutch province of North Brabant.

1869–1876

Works for art dealer Goupil & Cie and lives successively in The Hague, London and Paris.

1876–1880

Takes a series of jobs and lives for a while in England and later in Dordrecht, Amsterdam and the Borinage mining region in Belgium. His position in the Borinage is not renewed and he decides to become an artist. Immediately begins to practise drawing intensively.

1880

Moves to Brussels, where he takes drawing lessons at the academy and meets Anthon van Rappard.

1881

Moves back in with his parents in Etten and draws numerous peasant figures. Theo supports him financially.

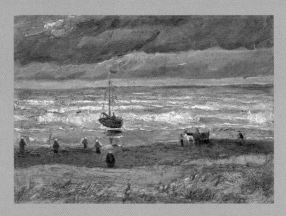

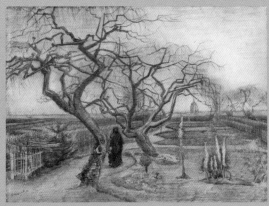

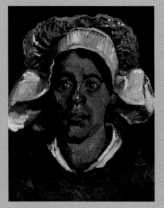

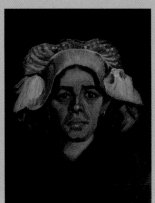

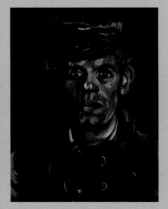

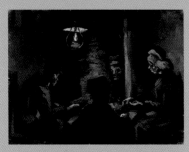

from left to right,
top to bottom:

View of the Sea at Scheveningen,
The Hague, 1882

Winter Garden, Nuenen, 1884

*Head of a Woman Wearing a White
Cap*, Nuenen, 1884–1885

Head of a Woman, Gordina de Groot,
Nuenen, 1885

Portrait of a Peasant, Nuenen, 1885

Study for 'The Potato Eaters',
Nuenen, 1885

The Potato Eaters, Nuenen, 1885

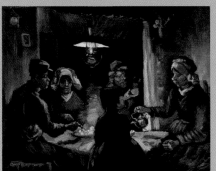

1881–1883

Moves to The Hague and takes drawing and painting lessons with Anton Mauve. Sets up a studio of his own and lives for a while with Sien Hoornik and her two children. When his relationship with Sien cools, he leaves for Drenthe in September 1883 to draw and paint in Hoogeveen and Nieuw-Amsterdam. Moves back in with his parents on 5 December 1883, this time in Nuenen. Uses the old scullery as a studio.

1884

Midway through the year, he rents two rooms from the Catholic sacristan Johannes Schafrat to use as a studio. Draws and paints a few landscapes but mainly weavers and peasants working the fields, as well as the garden of the parsonage and the church where his father Theodorus is minister. Paints his first studies of peasant faces in late October.

1885

By February, he has completed around thirty 'head studies'. Has the idea for *The Potato Eaters* when Theo invites him at the end of February to submit a painting for the Paris Salon. His father dies unexpectedly on 26 March.
Works on several drawn and painted sketches and studies for *The Potato Eaters* from the beginning of April. The finished painting has barely had time to dry before he dispatches it to Theo in Paris on 6 May, along with about a dozen studies.

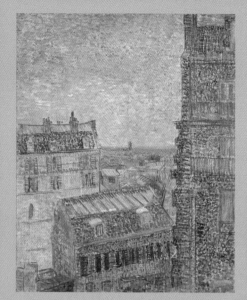

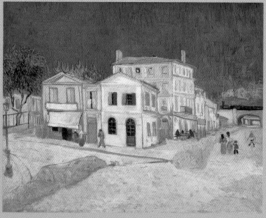

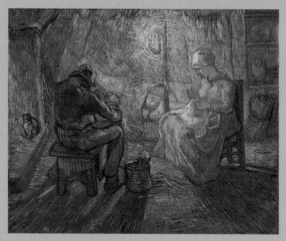

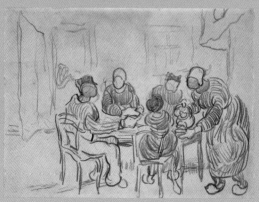

from top to bottom:

View from Theo's Apartment,
Paris, 1887

The Yellow House (The Street),
Arles, 1888

Evening (after Millet),
Saint-Rémy, 1889

*Interior with Five Figures Around
a Table*, Saint-Rémy, 1890

Following a row with his family, he leaves the parental home and goes to live in his studio. Moves to Antwerp in late November, where he takes drawing and painting lessons. At least 100 paintings and many drawings are left behind in Nuenen.

1886–1888

Travels to Paris in February 1886 and moves in with Theo at 25 rue Laval in Montmartre. They change address again four months later to 54 rue Lepic. Befriends the artists Henri de Toulouse-Lautrec, Emile Bernard and Paul Gauguin.

1888–1889

Moves to Arles in the south of France, where the bright colours inspire him. Gauguin comes to stay at the 'Yellow House' for two months, but there is considerable tension between the painters. Van Gogh suffers a mental breakdown and cuts off his ear.

1889–1890

Following a series of what appear to have been psychotic episodes, Van Gogh is admitted to an asylum in Saint-Rémy-de-Provence. He draws and paints intensively between breakdowns. In the spring of 1890, he becomes homesick for the Netherlands and produces drawings that are strongly reminiscent of *The Potato Eaters*.

1890

Moves to the village of Auvers-sur-Oise, near Paris. Completes a painting almost every day, but is unsure about his future as an artist. Shoots himself in the chest with a revolver and dies two days later, on 29 July, with Theo at his bedside.

Notes

1 Van Tilborgh 1993, pp. 30–31.
2 Louis van Tilborgh, 'Five parcels and three crates. The origins of the collection (1881–1885)', in Van Tilborgh and Vellekoop 1999, pp. 9–10.
3 De Brouwer 1984, pp. 23–24.
4 Van Tilborgh and Vellekoop 1999, p. 66.
5 Letter 436.
6 Van Tilborgh 1993, p. 31.
7 Letter 485.
8 De Brouwer 1984, pp. 12, 49.
9 Letter 419.
10 Letter 489.
11 Letters 267, 336, 430, 431, 434.
12 Letter 164.
13 Van Tilborgh 1993, p. 75.
14 Ibid., p. 31.
15 Ibid.
16 Van Tilborgh and Vellekoop 1999, p. 140.
17 Ibid., pp. 130–135.
18 Letter 494.
19 Jack van Hoek, 'Burger ziet meer in "Van Gogh" dan kunstkenner', *Eindhovens Dagblad*, 8 October 2015, see https://www.hhbest.nl/2015/10/08/burger-ziet-meer-in-van-gogh-dan-kunstkenner.
20 Van Tilborgh and Vellekoop 1999, p. 138.
21 Letters 499, 531, 574.
22 Van Tilborgh and Vellekoop 1999, p. 146.
23 Ibid., pp. 138–139.
24 Voskuil 1988, pp. 69, 88–89.
25 Letter 509. Van Tilborgh 1993, p. 35.
26 Letters 497, 500.
27 Van Tilborgh and Vellekoop 1999, p. 138.
28 Carol Jacobi, 'Black and White: Van Gogh's British Books and Prints', in Jacobi 2019, pp. 25, 47.
29 Van Tilborgh 1993, pp. 78–80.
30 Letter 291, n. 7.
31 Letter 445.
32 Letter 448.
33 Van Tilborgh and Vellekoop 1999, p. 142.
34 Letters 496, 497, 500.
35 Letter 501.
36 Letters 494, 497; Van Gogh Museum b900.
37 Letters 494, 497, 509.
38 Several impressions of the lithograph still exist, but the present location of the sketch is not known.
39 Letter 493.
40 Letter 497.
41 Letters 494, 497.
42 Letters 504, 514, 528.
43 Van Gogh Museum b939; Van Tilborgh 1993, p. 40.
44 Van Tilborgh 1993, p. 40.
45 Ibid., pp. 108–110.
46 Ibid.
47 Luijten 2019, p. 179.
48 Van Tilborgh 1993, p. 41.
49 Luijten 2019, p. 210.
50 'c'était d'une insigne laideur et d'une vie inquiétante...', Emile Bernard 1891.
51 Bremmer 1911, p. 103.
52 Havelaar 1911, p. 11.
53 Havelaar 1922, p. 157.

Cited Letters

The letter numbers included in square brackets after the quotations and in the notes refer to: Leo Jansen, Hans Luijten and Nienke Bakker (eds.), *Vincent van Gogh – The Letters: The Complete Illustrated and Annotated Edition*, Amsterdam, The Hague and Brussels 2009, and the online edition www.vangogh-letters.org and www.vangoghletters.org/vg/documentation.html

The 'b numbers' referred to in the notes are the inventory numbers of documents kept at the Van Gogh Museum:

Letter from Theo van Gogh to Anna van Gogh-Carbentus, Paris, 22 April 1885, Van Gogh Museum, b900

Letter from Theo van Gogh to Anna van Gogh-Carbentus, Paris, 1 June 1885, Van Gogh Museum, b939

Bibliography

Emile Bernard, 'Vincent van Gogh', *Les Hommes d'Aujourd'hui*, no. 390, vol. 8, Paris 1891

H.P. Bremmer, *Vincent van Gogh. Inleidende beschouwingen*, Amsterdam 1911

Ton de Brouwer, *Van Gogh en Nuenen*, Venlo 1984

Just Havelaar, *Het sociaal conflict in de beeldende kunst*, Haarlem 1922

Just Havelaar, 'Vincent van Gogh', *Onze Eeuw*, vol. 11, Haarlem 1911

Carol Jacobi (ed.), *Van Gogh and Britain*, exh. cat. London (Tate Britain) 2019

Hans Luijten, *Alles voor Vincent. Het leven van Jo van Gogh-Bonger*, Amsterdam 2019

Louis van Tilborgh (ed.), *The Potato Eaters by Vincent van Gogh. De aardappeleters van Vincent van Gogh*, Cahier Vincent 5, Amsterdam/Zwolle 1993

Louis van Tilborgh and Marije Vellekoop, *Vincent van Gogh: Paintings Vol. 1. Dutch Period, 1881–1885. Van Gogh Museum*, Amsterdam/Blaricum 1999

Louis van Tilborgh and Evert van Uitert, 'Van Gogh in search of his own voice', in Timothy J. Standring and Louis van Tilborgh (eds.), *Becoming van Gogh*, exh. cat. Denver (Denver Art Museum) 2012, pp. 15–43

Marije Vellekoop, 'From "Snot Tones" to "Sound Colours": Van Gogh and Colour Theory', in Ortrud Westheider and Michael Philipp (eds.), *Van Gogh: Still Lifes*, exh. cat. Potsdam (Museum Barberini) 2019, pp. 52–65

J.J. Voskuil, 'De verspreiding van koffie en thee in Nederland', *Volkskundig Bulletin*, vol. 14 (1988), pp. 68–92

List of Illustrated Works

Works marked with an asterisk (*) are included in the exhibition *The Potato Eaters: Mistake or Masterpiece?*. All the works from the collection of the Van Gogh Museum are the property of the Vincent van Gogh Foundation, with the exception of figs. 8 and 20.

Clément (Edouard) Bellenger

40 After Charles Paul Renouard, 'The industrial crisis in Lyon – Out of work'. In *L'Illustration. Journal Universel* 84 (25 October 1884), p. 268, wood engraving and letterpress on paper, 27.6 × 21.8 cm

Charles Degroux

16* *Saying Grace*, 1861
Oil on canvas, 80 × 154 cm
Royal Museums of Fine Arts of Belgium, Brussels

Gustave Doré

41 After Gustave Doré, 'An underground railway in London'. In *De Katholieke Illustratie* 10 (1876–1877), p. 141, wood engraving and letterpress on paper, 19.8 × 24.7 cm

Vincent van Gogh

5* Sketchbook in which Van Gogh made drawings and notes during his Nuenen period, November 1884–September 1885
Black chalk on paper, 12.4 × 15 cm
Van Gogh Museum, Amsterdam

6 *The Vicarage at Nuenen*, September–October 1885
Oil on canvas, 33.2 × 43 cm
Van Gogh Museum, Amsterdam

7 *Congregation Leaving the Reformed Church in Nuenen*, January–February 1884 and autumn 1885
Oil on canvas, 41.5 × 32.2 cm
Van Gogh Museum, Amsterdam

8 *Avenue of Poplars in Autumn*, October 1884
Oil on canvas on panel, 99 × 65.7 cm
Van Gogh Museum, Amsterdam
Purchased with support from the Vincent van Gogh Foundation and the Vereniging Rembrandt

9* *Peasant Woman Lifting Potatoes*, August 1885
Chalk on paper, 39.7 × 45.3 cm
Van Gogh Museum, Amsterdam

10 *Winter Garden*, March 1884
Pencil, pen and ink, on paper, 40.3 × 54.6 cm
Van Gogh Museum, Amsterdam

11 *Weaver*, December 1883–August 1884
Pencil, watercolour, pen and ink, on paper, 35.5 × 44.6 cm
Van Gogh Museum, Amsterdam

12 *Man Winding Yarn*, May–June 1884
Watercolour on paper, 44.8 × 35.4 cm
Van Gogh Museum, Amsterdam

14 *Saying Grace*, December 1882–April 1883
Pencil, black lithographic chalk, grey wash, brush in (printing) ink, oils and opaque watercolour on watercolour paper, 62.4 × 39.8 cm
Kröller-Müller Museum, Otterlo

17* Letter from Vincent van Gogh to his brother Theo with a sketch of *Potato Grubbers* (verso), c. 27 June 1883
Pen and ink, on paper, 20.9 × 13.2 cm
Van Gogh Museum, Amsterdam

18 *The Entrance to the Pawn Bank,
 The Hague*, March 1882
 Pencil, pen and brush and ink,
 watercolour, on paper, 23.9 × 33.7 cm
 Van Gogh Museum, Amsterdam

19 *Peasants Planting Potatoes*,
 August–September 1884
 Oil on canvas, 66.4 × 149.6 cm
 Kröller-Müller Museum, Otterlo

22* *Four People Sharing a Meal*,
 March–April 1885
 Chalk on paper, 20.9 × 34.6 cm
 Van Gogh Museum, Amsterdam

23* *Study for 'The Potato Eaters'*, April 1885
 Oil on canvas, 33.6 × 44.5 cm
 Van Gogh Museum, Amsterdam

24 *The Potato Eaters*, April 1885
 Oil on canvas on panel, 73.9 × 95.2 cm
 Kröller-Müller Museum, Otterlo

25* Letter from Vincent van Gogh to his
 brother Theo with sketch of *The Potato
 Eaters* (recto), 9 April 1885
 Pen and ink, on paper, 20.7 × 13.2 cm
 Van Gogh Museum, Amsterdam

26* *The Potato Eaters*, April–May 1885
 Oil on canvas, 82 × 114 cm
 Van Gogh Museum, Amsterdam

27* Letter from Vincent van Gogh to his
 brother Theo with sketch of *Head of a
 Woman* (Gordina de Groot), c. 28 May
 1885
 Pen and ink, on paper, 21 × 13.4 cm
 Van Gogh Museum, Amsterdam

29* *Clock, Clog with Cutlery and a Spoon
 Rack*, April 1885
 Chalk on paper, 34.5 × 21 cm
 Van Gogh Museum, Amsterdam

30* *Hand with a Pot, the Knob of a Chair and
 a Hunk of Bread*, April 1885
 Chalk on paper, 21.2 × 34.4 cm
 Van Gogh Museum, Amsterdam

31 *Three Hands, Two Holding Forks*,
 April 1885
 Chalk on paper, 21.3 × 34.6 cm
 Van Gogh Museum, Amsterdam

32 *Hand with a Bowl, and a Cat*,
 April 1885
 Chalk on paper, 21.2 × 34.4 cm
 Van Gogh Museum, Amsterdam

33* *Studies of the Interior of a Cottage,
 and a Sketch of The Potato Eaters*,
 April 1885
 Chalk on paper, 21.3 × 34.6 cm
 Van Gogh Museum, Amsterdam

34 *Head of a Young Man with a Pipe*,
 December 1884–May 1885
 Pencil on paper, 33.3 × 20.7 cm
 Van Gogh Muscum, Amsterdam

35* *Head of a Man*, December 1884–January
 1885
 Pencil, pen, brush and coarse brush
 and ink, on paper, 14.8 × 10.4 cm
 Van Gogh Museum, Amsterdam

36 *Head of a Peasant*, December 1884
 Oil on canvas, 39.4 × 30.2 cm
 Art Gallery of New South Wales, Sydney
 Art Gallery of New South Wales
 Foundation, purchase 1990

37* *Head of a Woman*, May 1885
 Oil on canvas, 43.5 × 36.2 cm
 Van Gogh Museum, Amsterdam

38* *Portrait of a Peasant*, March 1885
 Oil on canvas, 39 × 30.5 cm
 Royal Museums of Fine Arts of Belgium,
 Brussels

39* *Head of a Woman, Gordina de Groot*,
 March 1885
 Oil on canvas, 42.7 × 33.5 cm
 Van Gogh Museum, Amsterdam

42* *Head of a Woman*, November 1884–
 January 1885
 Oil on canvas, 42 × 33.3 cm
 Van Gogh Museum, Amsterdam

43* *Head of a Woman*, December 1884–
May 1885
Chalk on paper, 40.2 × 33.3 cm
Van Gogh Museum, Amsterdam

44* *Woman Sewing*, March–April 1885
Oil on canvas, 43.2 × 34.2 cm
Van Gogh Museum, Amsterdam

47* *Head of a Woman*, May 1885
Oil on canvas, 43.2 × 30 cm
Van Gogh Museum, Amsterdam

48* *Still Life with Vegetables and Fruit*,
autumn 1884
Oil on canvas, 32.3 × 43.2 cm
Van Gogh Museum, Amsterdam

49* *Still Life with Earthenware and Bottles*,
September–October 1885
Oil on canvas, 40.1 × 56.3 cm
Van Gogh Museum, Amsterdam

50* *Basket of Potatoes*, September 1885
Oil on canvas, 45 × 60.5 cm
Van Gogh Museum, Amsterdam

51 *Head of a Woman Wearing a White Cap*,
November 1884–May 1885
Oil on canvas, 44 × 36 cm
Kröller-Müller Museum, Otterlo

52 *The Head of a Peasant Woman*, 1885
Oil on canvas laid on millboard,
46.4 × 35.3 cm
National Galleries of Scotland, Edinburgh
Presented by Sir Alexander Maitland in
memory of his wife Rosalind, 1960

53 Sketch of *The Potato Eaters*, April 1885
Pen, ink and lithographic chalk on paper,
11 × 18 cm
Whereabouts unknown

54* *The Potato Eaters*, April 1885
Lithograph on paper, 26.5 × 32 cm
Van Gogh Museum, Amsterdam

55* *The Cottage*, May 1885
Oil on canvas, 65.7 × 79.3 cm
Van Gogh Museum, Amsterdam

56* *The Old Church Tower at Nuenen
('The Peasants' Churchyard')*,
May–June 1885
Oil on canvas, 65 × 80 cm
Van Gogh Museum, Amsterdam

57* *Interior with Two Figures Eating*,
March–April 1890
Pencil on paper, 24.4 × 32 cm
Van Gogh Museum, Amsterdam

58* *Interior with Five Figures Around a Table*,
March–April 1890
Pencil on paper, 23.2 × 32 cm
Van Gogh Museum, Amsterdam

59* *Evening (after Millet)*, October–
November 1889
Oil on canvas, 74.2 × 93 cm
Van Gogh Museum, Amsterdam

Jozef Israëls

15* *Peasant Family at the Table*, 1882
Oil on canvas, 71 × 105 cm
Van Gogh Museum, Amsterdam

Léon-Augustin Lhermitte

20 *Haymaking*, 1887
Oil on canvas, 215.9 × 265.8 cm
Van Gogh Museum, Amsterdam
Purchased with support from the Vincent
van Gogh Foundation

Jean-François Millet

13 *The Gleaners*, 1857
Oil on canvas, 83.8 × 110 cm
Musée d'Orsay, Paris
Donation subject to usufruct of Mrs
Pommery

Anthon van Rappard

21 *The Old Women's Home in
West-Terschelling*, 1884
Oil on canvas, 24 × 45.5 cm
Kunstmuseum, The Hague

Image Credits

The illustrated works, letters and documents from the collection of the Van Gogh Museum are the property of the Vincent van Gogh Foundation and are on permanent loan to the museum, with the following exceptions:

figs. 1–4: Archives Tralbaut
fig. 8: Purchased with support from the Vincent van Gogh Foundation and the Rembrandt Association
fig. 20: Purchased with support from the Vincent van Gogh Foundation

Photographic credits

The publisher has made every effort to comply with copyright regulations. Anyone believing that they are entitled to affirm rights is requested to contact the publisher.

pp. 3, 8: Schellens Bequest / Stichting C.R. Hermans. Brabant-Collectie, Tilburg University / photo Anton Schellens
pp. 4, 6, 98, 102: Regionaal Archief Tilburg / photo Henri Berssenbrugge
fig. 13: RMN-Grand Palais (musée d'Orsay) / photo Jean Schormans
figs. 14, 19, 24, 51: Kröller-Müller Museum, Otterlo / photo Rik Klein Gotink
figs. 16, 38: Royal Museums of Fine Arts of Belgium, Brussels / photo J. Geleyns – Art Photography
fig. 36: Art Gallery of New South Wales / photo AGNSW
fig. 45: Noordbrabants Museum / photo Peter Cox
fig. 52: National Galleries of Scotland / photo Antonia Reeve

Details

p. 2: Vincent van Gogh, *The Cottage*, May 1885 (see fig. 55)
p. 3: Woman peeling potatoes in the farmyard, the roofed part of which is covered with turf. Brabant-Collectie, Tilburg University
p. 4: Peasant family drinking coffee around a table, Tilburg, c. 1901. Regionaal Archief Tilburg
p. 5: Vincent van Gogh, *Study for 'The Potato Eaters'*, April 1885 (see fig. 23)
p. 6: Potato grubbing, Tilburg area, c. 1902. Regionaal Archief Tilburg
p. 7: Vincent van Gogh, *Peasant Woman Lifting Potatoes*, August 1885 (see fig. 9)
p. 8: A simple meal by the fireplace. Brabant-Collectie, Tilburg University
p. 9: Vincent van Gogh, *Interior with Two Figures Eating*, March–April 1890 (see fig. 57)
p. 10: Letter from Vincent van Gogh to Theo with sketch of *The Potato Eaters* (recto), 9 April 1885 (see fig. 25)
pp. 12, 14, 16–17, 18, 48–49, 54–55, 89: Vincent van Gogh, *The Potato Eaters*, April–May 1885 (see fig. 26)
p. 98: Peasant leaning out of a half-door, Tilburg, c. 1903. Regionaal Archief Tilburg
p. 102: Needleworkers at the back of the house, Tilburg, c. 1903. Regionaal Archief Tilburg

Cover illustrations

Vincent van Gogh, *The Potato Eaters*, April–May 1885 (see fig. 26)
Flap: A simple meal by the fireplace. Brabant-Collectie, Tilburg University (see p. 8)

This book was published on the occasion of the exhibition *The Potato Eaters: Mistake or Masterpiece?*, Van Gogh Museum, Amsterdam, 8 October 2021 – 13 February 2022

Text
Bregje Gerritse

Editorial Board
Nienke Bakker, Teio Meedendorp and Louis van Tilborgh

Publisher
Van Gogh Museum, Amsterdam

Head of Publications
Suzanne Bogman

Coordination
Monique den Ouden and
Roxanne van den Bosch, Van Gogh Museum
Barbara Costermans
and Ronny Gobyn, Tijdsbeeld

Translation
Ted Alkins

Copy-editing
Kate Bell

Design
Janpieter Chielens

Production management
Tijdsbeeld, Ghent

Photogravure, printing and binding
Graphius, Ghent
Typeset in Calibre and Berylium
Printed on Magno Volume 150 g

ISBN 978 94 93070 39 4
© 2021 Van Gogh Museum, Amsterdam

Distribution by Exhibitions International, Leuven
www.exhibtionsinternational.be

The exhibition and publication were made possible with the support of:

The Sunflower Collective